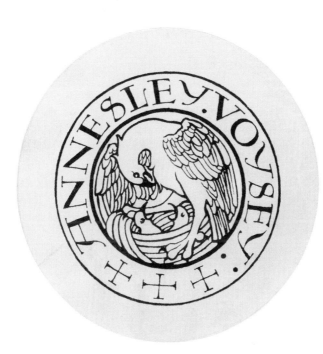

THE BOOKPLATES AND BADGES OF

C·F·A· VOYSEY

THE BOOKPLATES AND BADGES OF
C·F·A· VOYSEY

Architect and Designer of the Arts and Crafts Movement

Karen Livingstone

ANTIQUE COLLECTORS' CLUB
IN ASSOCIATION WITH
CRAB TREE FARM FOUNDATION

ISBN 978-1-85149-640-2

British Library Cataloguing-in-Publication Data
A catalogue record for this book is available from the British Library

Frontispiece. Bookplate for Robert Heywood and Margaret Dolores Haslam. Halftone print.
See Figure 63.

Printed in China
for the Antique Collectors' Club Ltd., Woodbridge, Suffolk

The Antique Collectors' Club

Formed in 1966, the Antique Collectors' Club is now a world-renowned publisher of top quality books for the collector. It also publishes the only independently-run monthly antiques magazine, *Antique Collecting*, which rose quickly from humble beginnings to a network of worldwide subscribers.

The magazine, whose motto is *For Collectors—By Collectors—About Collecting*, is aimed at collectors interested in widening their knowledge of antiques both by increasing their awareness of quality and by discussion of the factors influencing prices.

Subscription to *Antique Collecting* is open to anyone interested in antiques and subscribers receive ten issues a year. Well-illustrated articles deal with practical aspects of collecting and provide numerous tips on prices, features of value, investment potential, fakes and forgeries. Offers of related books at special reduced prices are also available only to subscribers.

In response to the enormous demand for information on 'what to pay', ACC introduced in 1968 the famous price guide series. The first title, *The Price Guide to Antique Furniture* (since renamed *British Antique Furniture: Price Guide and Reasons for Values*), is still in constant demand. Since those pioneering days, ACC has gone from strength to strength, publishing many of today's standard works of reference on all things antique and collectable, from tiaras to 20th century ceramic designers in Britain.

Not only has ACC continued to cater strongly for its original audience, it has also branched out to produce excellent titles on many subjects including art reference, architecture, garden design, gardens, and textiles. All ACC's publications are available through bookshops worldwide and a catalogue is available free of charge from the addresses below.

For further information please contact:
ANTIQUE COLLECTORS' CLUB
www.antiquecollectorsclub.com

Sandy Lane, Old Martlesham
Woodbridge, Suffolk IP12 4SD, UK
Tel: 01394 389950 Fax: 01394 389999
Email: info@antique-acc.com

6 West 18th Street, Suite 4B
New York, NY 10011
Tel: 212 645 1111 Fax: 212 989 3205
Email: sales@antiquecc.com

Contents

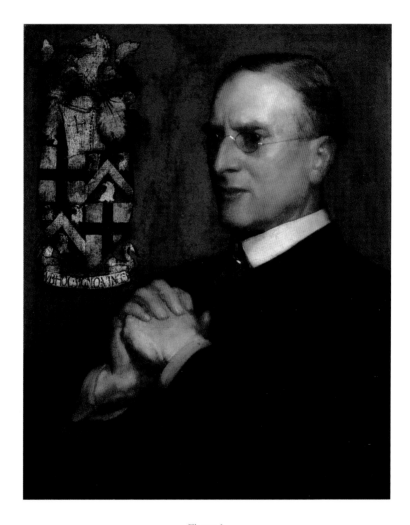

Figure 1
Harold Speed
Portrait of Charles Francis Annesley Voysey, 1905
Oil on canvas

Introduction

I n April 1932, Charles Francis Annesley Voysey, architect and designer of the Arts and Crafts Movement (Figure 1), returned to a favourite subject and spent some time pasting a collection of over one hundred of his own designs for bookplates, badges (emblems or logos) and greetings cards into a small album. This album became a personal record of his designs of this kind and it is now in the collection at Crab Tree Farm, near Chicago, Illinois (see page 46). Only a very few of these designs have previously been published, but each one encapsulates the spirit and underlying principles that informed every aspect of Voysey's architecture and decorative design.

From the very beginning of his career Voysey (1857-1941) established an unshakeable doctrine that informed his work in every medium. Whether in the houses he designed, or in his designs for furniture (Figures 2 and 3), wallpaper (Figure 4) and textiles (Figure 5), book-plates and badges, tiles, metalwork (Figures 6 and 7), wood and stone, his work possesses a consistent simplicity and harmony that is instantly recognisable.

Voysey's designs are a testament to his talent and importance as one of the leading architects and designers of his generation. His reputation and appeal were enhanced during his lifetime through the international publication of his designs, and he was always careful to professionally photograph and record his work. In the latter half of his life and career he also went to pains to write down the theories and principles that had guided him throughout his professional life. Between 1930 and 1932 Voysey wrote a manuscript entitled "Symbolism in Design", which is illustrated with many of the bookplates and badges that are also in the Crab Tree Farm album, each one accompanied by the designer's detailed description.[1] This manuscript is now held in the archives of the Royal Institute of British Architects (RIBA) in London, along with other important archival and source materials. Voysey also donated examples

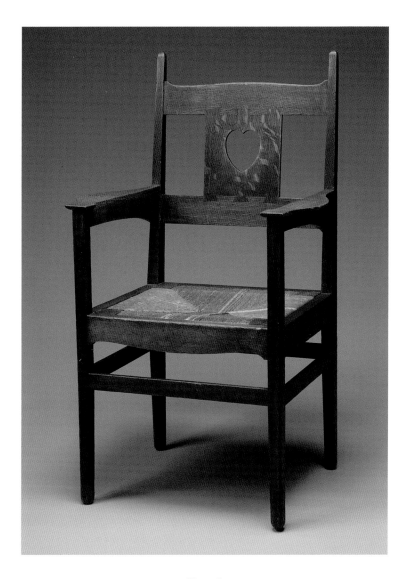

Figure 2
C.F.A. Voysey
Dining chair, designed 1902
Made by F.C. Nielsen, Buckinghamshire
Oak with rush seat
From the personal collection of the designer
COLLECTION OF CRAB TREE FARM

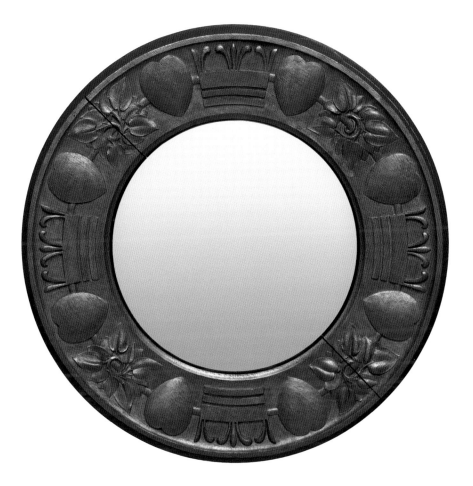

Figure 3
C.F.A. Voysey
Mirror, c.1900
Oak with gilding
From the personal collection of the designer
COLLECTION OF CRAB TREE FARM

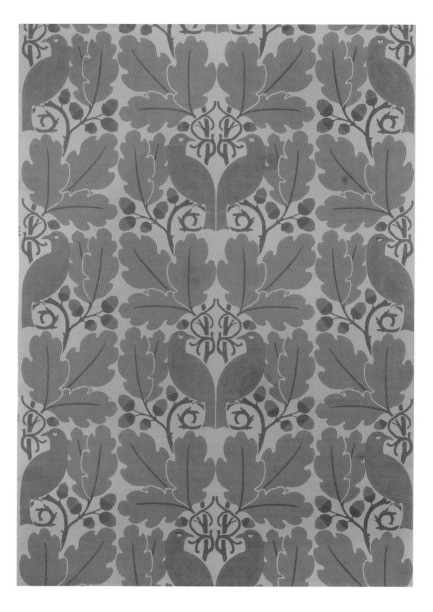

Figure 4
C.F.A. Voysey
Wallpaper, designed c.1890-1910
Made by Essex & Co., London
COLLECTION OF CRAB TREE FARM

Figure 5
C.F.A. Voysey
'Purple Bird' doublecloth, 1898
Manufactured by Alexander Morton & Co., England,
Silk and wool
COLLECTION OF CRAB TREE FARM

of his bookplate designs to the Victoria and Albert Museum and the British Museum, both in London, in a series of gifts made between 1913 and 1930, all the while corresponding with the curators of these institutions and keeping notes on the contents of each collection.

Together these collections of designs for bookplates and badges reveal much about Voysey's use of symbolism and the qualities he held as essential to good architecture and design. Moreover, the Crab Tree Farm album and the designs that Voysey selected to put in it offer a unique insight into his interests, personality, relationships with family, friends and clients, and work as a leading architect and designer of the Arts and Crafts Movement.

Bookplate History

Many books, articles and exhibitions have been devoted to the history of bookplates and bookplate collecting. A brief summary of this historical background is useful in that it provides some context for Voysey's work in this area.

A bookplate, or ex libris, is a label designed to be pasted inside a book as a means of identifying the owner. A good bookplate can also enhance the appearance of a volume and many are works of art in their own

Introduction

Figure 6
C.F.A. Voysey
Fireplace surround, c.1900
Possibly manufactured by Falkirk Iron Company
Cast iron
COLLECTION OF CRAB TREE FARM

14

Figure 7
C.F.A. Voysey
Hinge (one of a pair), c.1890-1900
Manufactured by Thomas Elsley & Co.
Brass
COLLECTION OF CRAB TREE FARM

right. Since the fifteenth century distinguished artists and patrons have given serious attention to this art form; Albrecht Dürer, Lucas Cranach the Elder and Hans Holbein the Elder were among its earliest proponents. Even before the invention of printing, a crest or coat of arms was often inserted into a bound volume or stamped on the binding to signify ownership. Until the late nineteenth or early twentieth century the armorial bookplate (which featured a coat of arms or family crest) remained the most common and popular type; it was often embellished with a simple label bearing the owner's name and perhaps an ornament around the edge.

Like the first printed books, the first printed bookplates originated in Germany, around 1450. Three bookplates of around this date are known, of which the earliest is probably the very rare woodcut bookplate of Hans Igler, a chaplain. Made by Johannes Knabensberg, this bookplate shows a hedgehog with a flower in its mouth (Figure 8). *Igel* is the German word for hedgehog, and the motto on the plate indicates that the hedgehog might "kiss" the viewer – a warning against stealing the book. Throughout history bookplates have played on names and imagery or included humorous twists, especially when aimed at sending a message to potential book borrowers. Sir Walter Scott's bookplates were printed with the phrase, "Please return this book; I find that though many of my friends are poor mathematicians, they are nearly all good bookkeepers".

From the sixteenth century bookplates were in use throughout Europe, although still in limited numbers. The earliest British bookplate

Introduction

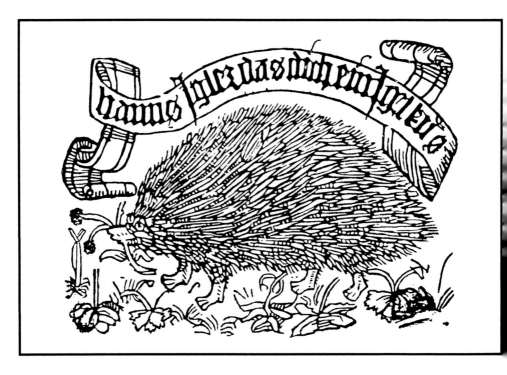

Figure 8
Johannes Knabensberg
Bookplate for Hans Igler, Germany, c.1450
Woodcut
14 x 19cm (5½ x 7½in.)
(Illustration shown at 70% of actual size)
COURTESY OF AMERICAN SOCIETY OF BOOKPLATE COLLECTORS AND DESIGNERS

is a coat of arms with an inscription that records the gift of Nicholas Bacon to Cambridge University Library in 1574. At least until the early nineteenth century people who commissioned bookplates usually came from the wealthy ruling classes of Europe; in other words, they could afford to own libraries.

In the seventeenth and eighteenth centuries bookplate design became more varied and pictorial styles developed alongside those of the armorial bookplate. Pictorial bookplates could employ virtually any image, but popular subjects included portraits of the owner or piles of books (Figure 9). When bookplates were at the peak of their popularity in the 1890s

Introduction

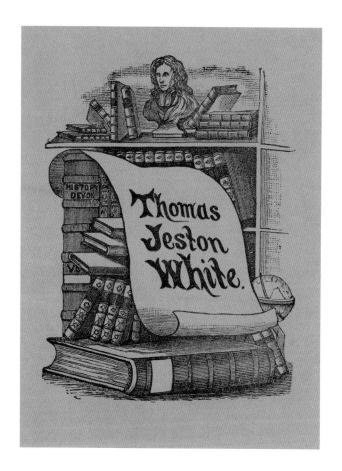

Figure 9
Designer unknown
Bookplate for Thomas Jeston White, England, c.1890
Engraving
11 x 8.2cm (4⁵⁄₁₆ x 3⁵⁄₁₆in.)
COLLECTION OF DR. GEOFFREY VEVERS

they began to be produced mechanically (and thus less expensively) in large numbers. The resulting poorly conceived designs – with an inappropriate and jumbled selection of images that were often brought together on cheap, commercially printed plates to create a pictorial summary of the owner – drew sharp criticism from one writer. He pointed out that it was unusual to follow a name – on letterhead or a calling card,

Introduction

17

for example – with a tag explaining that the person "Bicycles a bit, is fond of roses, sketches a little, keeps Bees, admires Egyptian art, is fond of reading, plays golf, [and] keeps a pet kangaroo."[2]

By the 1890s collecting bookplates had become a hugely popular pastime in the United Kingdom, parts of Europe, and the United States. One English collection of the period was said to include as many as 100,000 bookplates.[3] The Ex Libris Society was founded in London in 1891, with several hundred members joining in its first year. It held monthly meetings at which papers were read, examples of bookplates shown and demonstrations of various methods of printing given. The society also staged annual exhibitions. Many other bookplate societies were founded around this time as well, notably in Berlin (called The Ex Libris Society), also in 1891. Today bookplate societies continue to thrive around the world – in almost every European country and across the United States, Canada, Brazil, Australia, China and Japan.

The Ex Libris Society published a monthly journal and numerous pamphlets and books on bookplate history.[4] Articles on increasingly specialised categories such as ladies' armorial bookplates began to appear in the 1890s. Popular weekly and monthly magazines in Britain and America also frequently reproduced bookplates and published articles on the subject to meet the demands of a hungry market. Most of these journals fed the interest of collectors who focused on particular categories or rare examples of bookplates and seldom addressed questions of design. The progressive design journal *The Studio* was a notable exception. The first issue of *The Studio*, in 1893, included an article on designing for bookplates, written by the founding editor, the avid bookplate collector Gleeson White, and bookplates soon became a regular feature in the magazine.

The fashion for collecting bookplates and the activities of bookplate societies drew some criticism from the design world in the late nineteenth century, raising concerns that the quality of design and production had suffered as a result. White went so far as to criticise the Ex Libris Society directly for not actively trying to promote good design in this field, despite having some notable artists and designers among its membership, and for the prominence it gave to the "rubbish" displayed in its annual exhibitions.[5] These were strong words, but the arguments

about quality of design and technique echo the criticisms levied by members of the Arts and Crafts Movement about aspects of modern and industrial design and manufacture at that time.

Arts and Crafts Bookplates

Throughout every era there have been some outstanding artists and designers of bookplates and their designs often reflect current fashionable styles in architecture and the decorative arts. From the mid-nineteenth century a number of talented and prominent artists and designers contributed new ideas and approaches to bookplate design.

At the same time, Charles William Sherborn and George W. Eve led a renaissance of the more traditional engraved armorial style of bookplates (Figure 10). The type of armorial plates they specialised in were finely detailed, very expensive to produce and did not lend themselves to cheap reproduction. In addition to Voysey, a number of artists connected to the Arts and Crafts Movement designed "modern" or pictorial bookplates, including Robert Anning Bell, Frank Brangwyn, Edward Burne-Jones, Walter Crane, Lewis F. Day, Georgie Cave Gaskin, Ernest Gimson, Kate Greenaway, Herbert Horne, Jessie M. King, W.R. Lethaby, Margaret Macdonald, Joseph Southall, Charles Harrison Townsend, Aymer Vallance and Emery Walker.

For some of these designers bookplate design was something they attempted only once. For example, in 1898 the architect, designer and craftsman Ernest Gimson designed a bookplate for his brother Sydney, also an architect and furniture maker (Figure 11). Inexperienced at drawing flat pattern designs for reproduction, Gimson confessed that he found the process difficult, writing to his brother on 9 March 1898: "I have done what I can with the book plates and send you the results. They are neither of them satisfactory. . . . I don't understand designing for reduction. And it would require a more microscopic eye than mine to draw it real size".[6]

The Glasgow artist and designer Jessie M. King drew around thirty different designs for bookplates between 1902 and 1910. Some of these were specially commissioned, while others were drawn as gifts or designed for exhibition with the intention of attracting sales or further commissions (Figure 12).[7] Robert Anning Bell, Walter Crane,

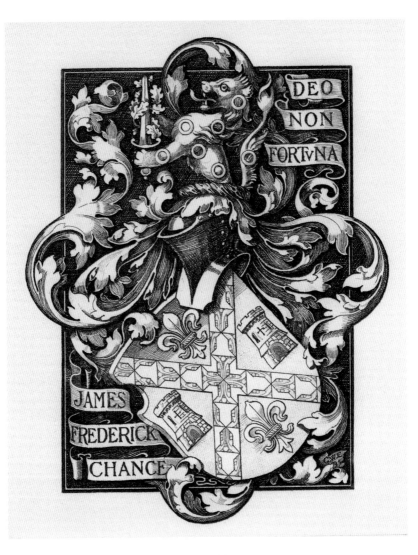

Figure 10
George W. Eve
Bookplate for James Frederick Chance, England, 1895
Copper engraving
13.7 x 11cm (5⅜ x 4⁹⁄₁₆in.)
COLLECTION OF DR. GEOFFREY VEVERS

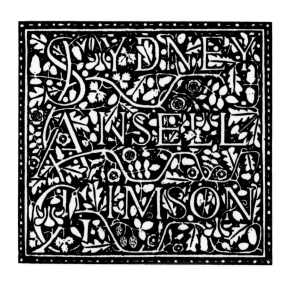

Figure 11
Ernest Gimson
Bookplate for Sydney Ansell Gimson, England, 1898
Ink on paper
6.5 x 6.5cm (2⁹⁄₁₆ x 2⁹⁄₁₆in.)

George W. Eve and Aymer Vallance were among those who exhibited their bookplate designs at the London exhibitions of the Arts and Crafts Exhibition Society. Harold Nelson – a successful artist, illustrator and designer who trained at the Lambeth School of Art and the Central School of Arts in London and was strongly influenced by both Dürer and William Morris – regularly published his bookplates in journals and newspapers. He also exhibited at the Arts and Crafts Exhibition Society and was awarded a silver medal for his bookplate designs in the 1896 National Competition (a competition for students run by the National Art Training School in South Kensington to encourage designing for industry).

Subsequent competitions similarly resulted in designs by students for bookplates that attracted commendation, thereby suggesting that the bookplate was considered an appropriate graphic art form within the art school system of the period. Further recognition of bookplates as a form of graphic art was given through monthly design competitions run by *The Studio*, the results of which were occasionally published in the journal's pages.[8]

The Studio aimed to publish "new examples from time to time of such plates as endeavour to raise the average standard", and the bookplates of many artists and designers associated with the Arts and Crafts Movement appeared in its pages, including those of Voysey.[9] In 1915 the magazine observed that:

> It is not surprising … that he [Voysey] should have bestowed his attention on a class of design which, if lying outside the broad ambit of his practice as an architect, is yet one calling for the play of decorative facility which he possesses in such a marked degree … from a number which he has designed from time to time this faculty is well manifested in combination with a felicitous appreciation of the symbols appropriate to the particular case.[10]

Bookplates and badges did, in fact, provide an ideal format for Voysey to exploit the language of symbolic motifs that he had developed. He strongly believed in the moral and symbolic meaning that could be held within a design, and this underpinned his work as an architect and

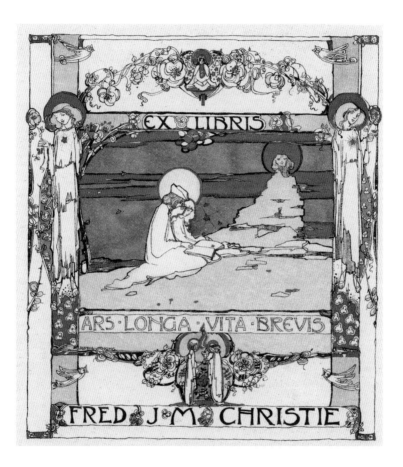

Figure 12
Jessie M. King
Bookplate for Fred J.M. Christie, 1906
Print in black, white, blue, beige and gold ink
11.1 x 11cm (4⅜ x 4⅜in.)

decorative designer throughout his career. The same ideas and motifs informed every aspect of his designs, whether he was creating a country house, a chair, wallpaper or a bookplate.

C.F.A. Voysey: Architect and Designer

In 1874, when he was seventeen years old, Voysey was articled (apprenticed) to the office of the architect J.P. Seddon for five years. At that time there was no formal training for architects and the system of apprenticeship offered him an opportunity to develop his skills under the guidance of one of the pioneering architects of the Gothic Revival. It also introduced him to the network of architects and designers who were the founding fathers of the Arts and Crafts Movement and would influence and shape the future direction of his work.

Voysey came from a large family – he was the eldest son of ten children – but he grew up largely in the company of his father, Charles Annesley Voysey, a minister. Through his father, who was expelled from the Anglican Church in a highly publicised scandal and left his Yorkshire home to set up his own theistic ministry in London, Voysey learned about the uncompromising certainty of belief. Unwavering conviction was a trait he carried with him throughout his life and work. He was also introduced, through his father and grandfather, to the writings of John Ruskin and the architecture of A.W.N. Pugin. Ruskin's influential text *The Stones of Venice* (1851-53), particularly the chapter "The Nature of Gothic", was the cornerstone on which Arts and Crafts ideals were later founded. Pugin's version of Gothic, drawn from the Middle Ages, was instilled with Christian moral ideology. To Voysey, whose grandfather was an architect and engineer who had known and admired Pugin, "No living architect of his time could compare with him for knowledge of that style".[11]

Voysey became a determined and sometimes blunt advocate of Gothic architecture – as opposed to classical architecture, which he considered to be "foreign" – but there was another aspect of Pugin's life that attracted his interest. Pugin was not simply an architect, he was also a designer who worked in many different media (Figure 13). This was a revelation to Voysey, who followed not just in the footsteps of Pugin but also in those of the generation of architects who followed him including G.F. Bodley, William Burges, E.W. Godwin and A.H. Mackmurdo, all

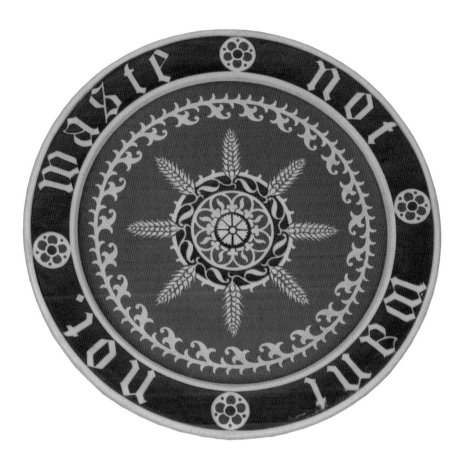

Figure 13
A.W.N. Pugin
Bread plate, c.1850
Manufactured by Minton & Co., England
Earthenware

of whom produced designs for wallpaper, furniture and metalwork for limited mass-production. Voysey no doubt also learned much about decorative design from Seddon and his circle during the five years of his apprenticeship and he readily acknowledged their influence on his future as an architect and designer for whom nothing in the home was too small to design.

Introduction

In 1882 Voysey set up his own architectural practice, specialising in domestic architecture, based on the needs and lifestyles of his clients (Figure 14). His domestic and international reputation was advanced with the help of journals and magazines such as *The Studio*, which regularly published his work, as well as his participation in exhibitions at home and abroad. By some accounts he was a single-minded and uncompromising architect with a stern professional demeanour, but he also took pride in the fact that he had many repeat clients and some of the bookplates he designed are testaments to the fact that he forged strong bonds and lasting relationships with his clients.

Voysey was an architect of his time. He designed small houses that suited the practical needs of his clients, who were often enlightened professionals from the new middle classes, with artistic tastes. He developed a simple and consistent architectural style that drew on tradition but was very much intended to reflect modern lifestyles and which was greatly admired internationally. Houses such as Broadleys in Windermere (Figure 15), designed for Arthur Currer Briggs, a colliery owner (see Figures 42 and 43), featured in the influential book on British domestic architecture of the Arts and Crafts period *Das Englische Haus* by Hermann Muthesius (1904). The house was praised for its individuality and unity of approach. In 1898 Voysey designed his own home, The Orchard, in Chorleywood, within commuting distance of London (Figure 16). This was to become a showcase for future clients as well as his family home. Although designed on a limited budget, The Orchard was the ultimate Voysey home, and he designed every aspect of it, inside and out. It was a special place, and he featured it on the bookplate he designed for his wife, Mary Maria (see Figure 26).

In his work as an architect and designer, Voysey embodied many of the ideas of the Arts and Crafts Movement and he was one of the pioneers who took up the call from Ruskin and Morris to improve the lives of ordinary people through the design of everyday objects. Although a reluctant admirer of Morris's pattern designs, Voysey quite clearly wanted to distance himself from the great man and his ideals, partly because he did not approve of his socialist beliefs. The two men also differed in their approach to design: while Morris was a practising craftsman, Voysey understood technique and was a skilled designer but

Introduction

26

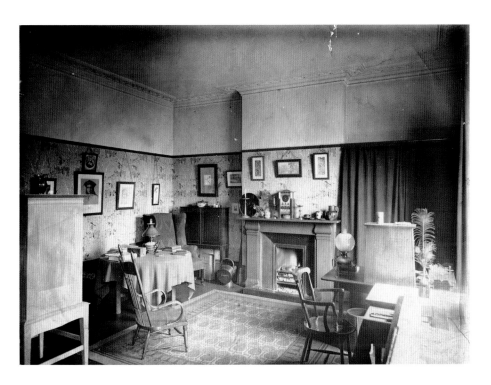

Figure 14
Voysey's office at his home in St. John's Wood, London, c.1893
RIBA LIBRARY PHOTOGRAPHS COLLECTION

did not actually make anything himself. Like his mentor and predecessor A.H. Mackmurdo, the architect, designer and founder of The Century Guild, Voysey designed for industry and limited commercial production. He liked to work with the same manufacturers, craftsmen and builders on a regular basis, including W.B. Reynolds for metalwork, William Aumonier for woodwork and carving (see Figure 67), and the building contractors Frederick and George Müntzer (see Figure 64).

Although he did gradually start to attract clients and build an international reputation as an architect, Voysey initially had to find a way of generating income while his practice established itself, not least because he needed to support his new wife and family after marrying in

Introduction

27

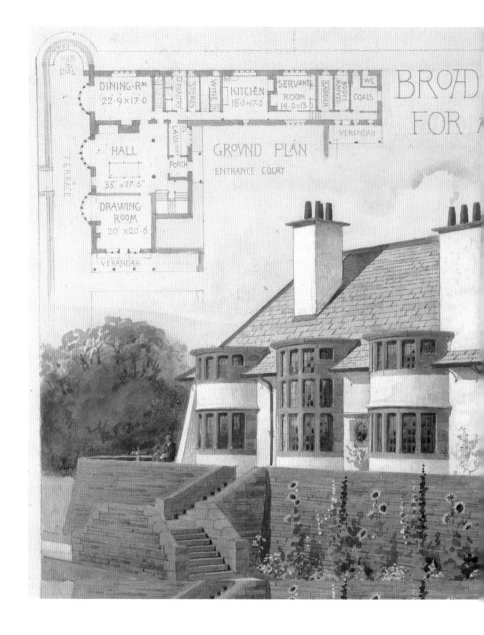

DINING·R^M
22·9×17·0

PANTRY

STORES

WINE

KITCHEN
18·0×17·0

SERVANTS
ROOM
14·0×13·0

LARDUR

BOOTS
KNIVES

W·C

COALS

DIAL

TERRACE

HALL
35'×27·6"

LAVATORY

PORCH

GROUND PLAN

ENTRANCE COURT

VERANDAH

DRAWING
ROOM
20'×20·6

VERANDAH

BROAD

FOR

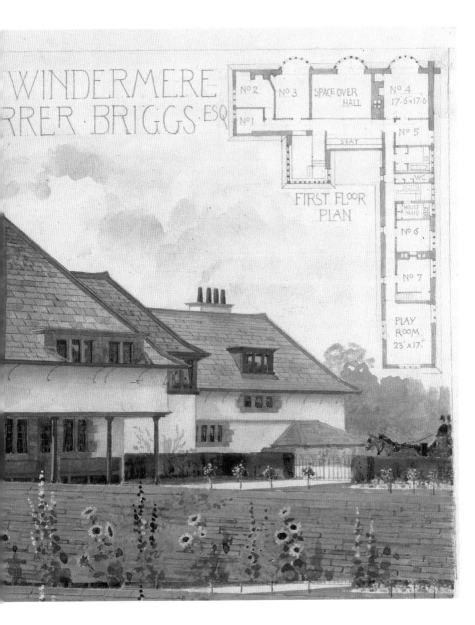

WINDERMERE
RRER · BRIGGS · ESQ

No 2 No 3 SPACE · OVER
 HALL No 4
No 1 17'·6 × 17'·0

 SEAT No 5

FIRST FLOOR WC
PLAN HOUSE
 MAID

 No 6

 No 7

 PLAY
 ROOM
 23' × 17'

Figure 15
C.F.A. Voysey
Design for Broadleys, Windermere, for Arthur and Helen Currer Briggs, 1898
Drawing in watercolour and ink

Figure 16
The hallway of C.F.A. Voysey's own home
The Orchard, Chorleywood, near London, 1899
RIBA LIBRARY PHOTOGRAPHS COLLECTION

1895. Mackmurdo, whose home Voysey visited regularly as a young man, taught him how to design repeating flat patterns and he quickly showed a natural instinct and talent for this type of work. Soon he was selling his designs to some of the more artistic manufacturers, such as Jeffrey & Co. (who also produced designs by Mackmurdo, Burges and Godwin), and he secured regular contracts with wallpaper manu-facturer Essex & Co. and textile manufacturer Alexander Morton & Co. (see Figures 17 and 46). His wallpaper and textiles were so successful that these companies flourished. He also sold patterns to many more companies and attracted international attention. Some of his earlier patterns are credited with influencing the development of European Art Nouveau, although he himself disapproved of the style and called it

Introduction

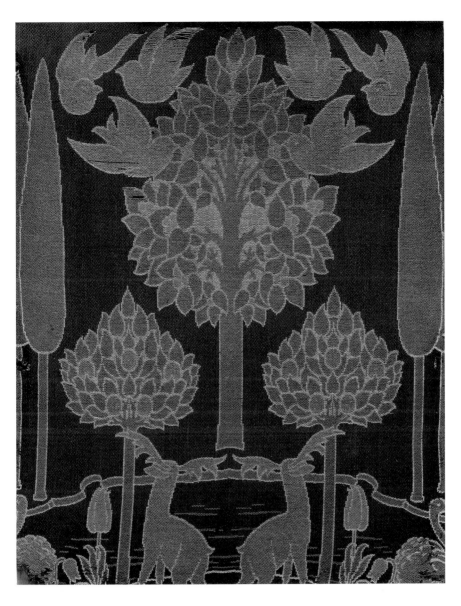

Figure 17
C.F.A. Voysey
Sample of furnishing fabric in 'Duleek' pattern, c.1896
Manufactured by Alexander Morton & Co., England
Woven wool

"unhealthy and revolting"; his reputation and influence, both as an architect and as a decorative designer, came to be felt in Austria, Germany, Holland, Scandinavia and the United States.

Voysey's output of flat pattern design was prolific, aided by the speed at which he was able to realise his ideas on the drawing board and by his understanding of the technical requirements of drawing repeating patterns. Hundreds of his designs survive, and these helped to sustain his business and enhance his reputation. By the mid-1890s his decorative vocabulary – based around hearts, trees and birds, each with its own symbolic meaning – was firmly established. Making frequent visits to London Zoo to study animals and birds, Voysey excelled at observing from nature and then paring down a motif to its most concentrated form; one commentator noted that Voysey's version of a particular bird was more like the bird it depicted than the actual bird itself.[12] The motifs he used were highly tuned and limited to a consistent vocabulary that he repeated in many different configurations. The result was an emphasis on outline with minimal detail, yet his designs still contain a great deal of expression and character. The key to Voysey's pattern design was precise observation combined with simplicity and restraint, and he commented, "To be simple is the end, not the beginning of design".[13]

An early example of Voysey's use of symbolism in design can be seen in a project that he worked on while still an apprentice in the office of Seddon. In 1887 Voysey was asked to work up a design for a mosaic for the new University College of Wales in Aberystwyth, one of the most famous Seddon buildings and a large commission for his office at that time. In Voysey's design for a mosaic triptych for the exterior of the university's new science block, the simplicity of line and flat style that were to become so characteristic in his work are evident, and his use of symbolism is absolutely explicit. The three mosaics represent the relationship between pure and applied science (Figure 18). Perhaps influenced by the unorthodox religious doctrine of his father, Voysey's original design commented on the conflict between science and religious dogma by including the symbols of sacredotalism at the feet of the bearded central figure of Science. This design proved to be more than a little controversial, and some months later, after the college realised

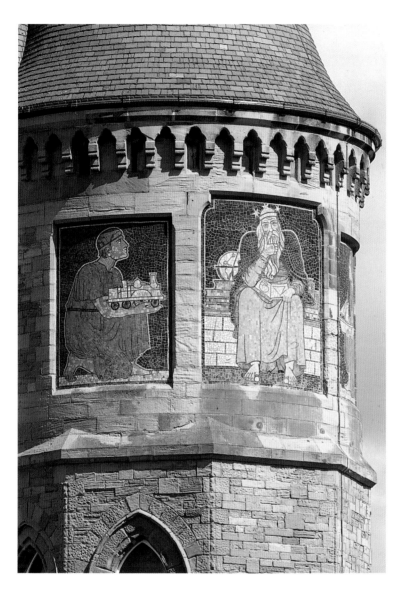

Figure 18
Mosaics on the Northwest Tower at Old College, Aberystwyth, Wales
Designed by Voysey while an apprentice in the office of J.P. Seddon, 1887

what it meant, Seddon was ordered by the University Building Committee to remove the symbols that Voysey had worked into his design. The finished mosaics were much simpler in execution, but Voysey recounted this incident almost with a hint of triumph in his autobiographical notes,[14] despite the fact that the designs were described as "unfortunate" and the mosaic panels only survived because it later proved too expensive to have them removed.[15]

Six years later, in 1893, when he designed the cover for the first issue of *The Studio*, Voysey's drawing style was fully evolved, and the design for this exciting new magazine was full of the character and symbolism that also defines his designs for bookplates and badges (Figure 19). The cover shows the figures of Use and Beauty. Many years later Voysey explained the meaning of the design, noting that: "The Governor of a steam engine is held in the hand of the male figure typifying useful control, while beauty being the more gentle is female. She holds the lily of purity, both live in the midst of nature under the rose tree which denotes love. They are kissing each other while a halo of little messengers surround the two."[16]

A precedent to this style of design, loaded with enigmatic symbolism and meaning, were the woodblock designs of Herbert Horne and Selwyn Image, made for *The Hobby Horse*, the innovative magazine first produced by The Century Guild in 1884 (Figure 20). It was the first journal intended to be a work of art in its own right, with everything from the type and the size of the margins, to the illustrations and their distribution on the page, beautifully considered and designed. As a young man, Voysey studied the magazine and its illustrations closely, and he later wrote that "the extent of its influence was impossible to measure."[17] Voysey also had a keen interest in lettering, and in 1895 he devised his own typeface, which he used consistently for the rest of his life (Figure 21).

Voysey's design for the cover of *The Studio* very much resembles the style of his bookplates, and it was later adapted, in colour, as a poster by the Central Control Board (Liquor Traffic), for which Voysey volunteered during World War I. The artist regularly reused symbols and motifs, repeating and reworking the same designs over and over again to produce the consistency that makes his work immediately recognisable yet individual and fresh.

Introduction

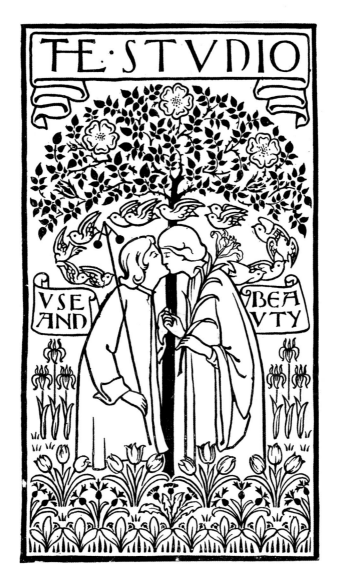

Figure 19
C.F.A. Voysey
Design for the cover of the first issue of *The Studio*, 1893

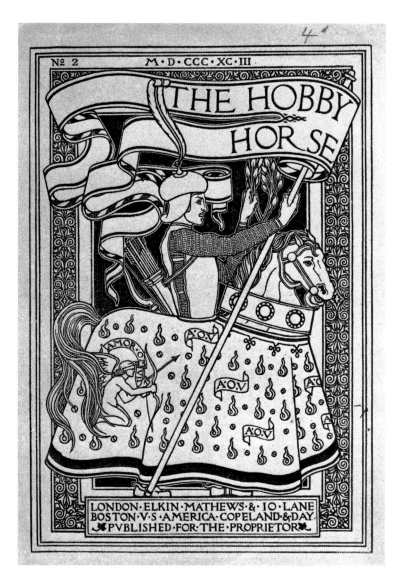

Figure 20
Cover of *The Hobby Horse*, first published by The Century Guild, London, 1884;
reissued 1893

His designs for bookplates and badges are variations on a limited number of shapes, styles (armorial or pictorial) and subjects. Favourite combinations included a heart, crown or band, and tree. Other common symbols from the lexicon he devised include the fleur-de lis (purity), the lyre (music), a proportional compass (architecture), an olive branch (peace), scales (justice) and especially birds. The raven represented sagacity, while the eagle was "the highest flier and furthest seer",[18] and swallows represented faithfulness and constancy. Many of these motifs and designs, which form the basic vocabulary of his bookplates, appear in his designs of all kinds – especially his textiles and wallpaper – and were repeated in work made throughout his lifetime.

The first issue of *The Studio* included the first major published article on Voysey's work; the journal initially reported on his wallpaper designs and then in future issues promoted his architecture. Voysey stood out from many of his contemporaries for his clever use of publicity in the British and international magazines that featured his work, and for his own writing and lecturing. Although he claimed reticence on this front, he nevertheless made the most of competitions and magazines as a means of drawing attention to his work, with the hope of attracting new clients. Voysey and his generation were active in establishing societies and networks through which ideas could be exchanged and connections formed; these societies also provided more formal representation for their growing professional body.

Voysey belonged to the vibrant circle of architects, designers, artists, craftsmen and patrons of the Arts and Crafts Movement. He was a member of the Art Workers Guild from its foundation in 1884 (serving as Master in 1924) and of the Arts and Crafts Exhibition Society, founded in 1887, which gave the movement its name. With Lindsay P. Butterfield, Lewis F. Day and Arthur Lasenby Liberty, Voysey was a founding member of the Design Club, an organisation for architects who designed their own interior furniture and decorations (see Figure 119), and he was also a founding member and volunteer for The Imperial Arts League, a trade union for artists and craftsmen (see Figures 125 and 126).

His address book was full of prominent Arts and Crafts practitioners whom he counted among his friends, as well as of clients, many of whom

123456
ABCDE
LMNOP
VWXY

Figure 21
C.F.A. Voysey
Blueprint design for lettering and numbers, c.1895
From the personal collection of the designer

were Quakers. They spent evenings dining at the Arts Club in Dover Street (see Figures 120-123) or at the monthly suppers of the St. John's Wood Arts Club, and attending lectures at the RIBA (see Figure 135) or the Art Workers Guild.

Voysey, who had a reputation for being outspoken, no doubt talked earnestly on such evenings about the values that underpinned his design, and in 1915 he published the book *Individuality* (see Figure 142), in which he set out his fundamental belief in faith as the constant element underpinning both his life and work – "the love of God leads to the love of goodness, truth and beauty, and ultimately to the joy of symbolising these qualities in all design."[19] Already by this time, however, his views were starting to be considered a little out of date.[20]

Between 1930 and 1932 Voysey filled his spare time by working on a manuscript on the subject of symbolism in design, with various subtitles such as "Ideas for Bookplates and Badges" or "Bookplates, Symbolism and Philosophy" and it was certainly a subject that occupied him over many years.[21] An earlier version of the manuscript was presented as a lecture at the Carpenters' Hall, London, and published in *The Builder* in 1918 and 1929, illustrated with examples of Voysey's designs for bookplates and badges. In "Symbolism in Design", Voysey directed the viewer, when looking at his bookplate and badge designs, to "not be concerned with the question as to the authorship of the designs … or to question their artistic merits or demerits, but concentrate his attention on the ideas they display, which are the common properties of all."[22]

Another important source of information about Voysey's bookplates and other designs is the "Black Book", the designer's personal record of his paid work (now in the archives of the RIBA), as well as his book of expenses, known as the "White Book". These books record the fact that some of Voysey's designs for bookplates and badges were commissioned and paid for. The remainder were drawn for his own occupation and as gifts for members of his family, friends and clients, sometimes to commemorate a marriage or a birthday.

To gather source material for his designs, Voysey would make visits to the British Museum library and manuscripts collection, where he copied angels from illustrations of paintings by Filippo Lippi, and portraits of men wearing hats from a book on Leonardo da Vinci by Eugène Müntz.

Introduction

He also studied Pugin's *Glossary of Ecclesiastical Ornament* and sketched angels from volumes such as *Miscellaneous Tracts Relating to Antiquity*, published by the Society of Antiquaries. He made a particular study of heraldry, using standard texts such as Charles Boutell's *Manual of Heraldry* (first published in 1863), and he produced many sketches, tracings and notes on armorial symbols and designs based on historic examples in the British Museum. His research included a study of his own family origins and coats of arms; he compiled these for later use in a bookplate for his son (see Figure 27) and Harold Speed (see Figure 72) used it as a background to the portrait he painted of Voysey (see Figure 1). He also drew his own family tree, tracing his connection to John Wesley, founder of the Methodist Church. All of the sketches and studies he made formed part of a folio of resource material and a lexicon of symbols that were translated directly into his designs for bookplates and badges, and his pattern designs for textiles and wallpaper.

When working out an idea for a new bookplate, Voysey would sketch something in pencil on a piece of brown paper, a page torn from a notebook, the back of a card or a piece of headed writing paper from the Arts Club. We can perhaps imagine him sitting in a corner at his club on Dover Street, dressed in a collarless blue jacket of his own design, pencil in hand, working out new designs and combinations of symbols as he sipped a glass of sherry and called out greetings to or exchanged anecdotes with passing friends and fellow club members.

These sketches were annotated with comments about the symbolism of each motif, or notes about colour or a suitable quotation or motto (Figures 22 and 23). The final designs were drawn up at a large scale, sometimes with variations from the original idea. The finished drawings, on thick tracing paper, were marked with instructions for the printer: "Prints to be cut down to leave a margin as indicated by the pencil line" or "Pay special attention to the Coat of Arms on the Coach and Coachman's Seat". When necessary, Voysey sought approval from his client and then the finished drawings were sent off to a commercial printer, such as The Ferrestone Press in London, where they were reproduced, usually by electrotyping. The proofs were returned to Voysey for checking before he ordered the final print run.

Although not entirely a commercial occupation, this area of his design

Introduction

SUCH·ART·KI-
LLING·CARE·&·GRIEF
·OF·HEART·
·IN·SWEET·MUSIC·IS

FANNY·CRUMP.

Its sweet music's such art-killing care, & grief of heart. King H.7.VIII act. III.1.

It was the lark, the herald of the morn, act. III.5.

The Lark Alauda arvensis
Famous for its affection
for its owner. & gladsome
& heart-lifting notes.

SC172/VOY [470]

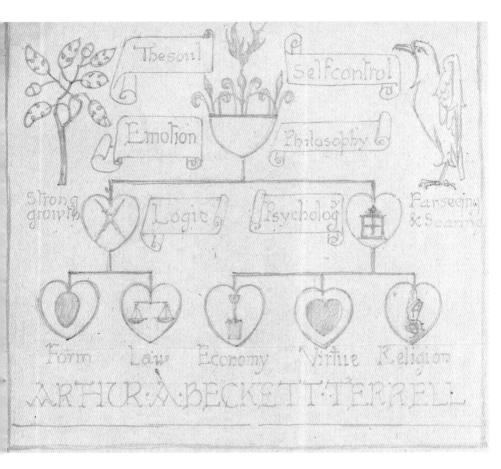

Figures 22 and 23
C.F.A. Voysey
Working sketches for the bookplates of Fanny Crompton and Arthur À Beckett Terrell
1918 and 1917 respectively

work was of enough significance that it was referred to in the obituary published in *The Builder* on his death in 1941, which noted, "He admired and understood the art of heraldry, and was a particularly successful designer of bookplates, a collection of which is in the British Museum. Many of these he drew for friends – all too frequently without remuneration ... the earning of money was secondary to him."[23]

Money problems certainly troubled Voysey in his later career and in 1906 he was forced to sell The Orchard as his architectural practice began to decline. He moved with his wife and three children into a rented home near his father and the children's school in Hampstead, London. In 1917, as his health and marriage deteriorated, he took a flat in St. James's Street, in central London, where he lived alone until shortly before his death in 1941.

Voysey's career dwindled after 1912, as much because of his own consistent and intractable approach as because of the changing fashions after World War I. Despite this, he remained one of the most original and influential British architects and designers of the Arts and Crafts Movement. By the 1930s Voysey was being "rediscovered" and hailed as a precursor to the modern movement, although he would not accept the association and thought that modern architecture was "vulgarly aggressive" (Figure 24).[24] He was more proud of being one of the first people to be made a Designer for Industry by the Royal Society of Arts in 1936. In 1940, at the age of eighty-three, he was finally awarded one of the highest accolades of the architectural profession, the RIBA Gold Medal.

Voysey was perhaps both slightly bemused by, and equally proud of, the public recognition that he received in his later life, but, within the Crab Tree Farm album of bookplates and badges, a broader, more celebratory and sometimes more personal picture is drawn. Together the bookplates and badges he pasted into this unassuming notebook, and all the associations they contain, create a portrait of a clear-sighted and individual architect and decorative designer of extraordinary talent and influence. They describe someone who valued the importance of family and friends, and who was actively engaged in, and an outstanding leader of, the professional and social world of avant-garde architecture, art and design that flourished in Britain during the period.

Introduction

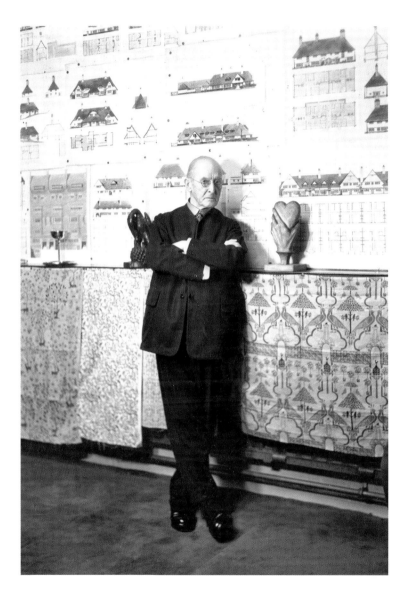

Figure 24
C.F.A. Voysey at an exhibition of his work hosted by *The Architectural Review* at the Batsford Gallery, London, 1931

The Crab Tree Farm album of Bookplates and Badges
by C.F.A. Voysey, compiled 1932
From the personal collection of the designer
21 x 13.3 x 2.9cm (8¼ x 5¼ x 1⅛in.)

(Illustration shown at 65% of actual size)

The Voysey Family

Figure 25
CHARLES FRANCIS ANNESLEY VOYSEY, n.d.
Print on grey paper
8.1 x 4.3cm (3³⁄₁₆ x 1¹¹⁄₁₆in.)

For his own bookplate, printed in green ink on grey paper, Voysey used his most characteristic and personal emblems: birds and a heart. Birds featured in Voysey's pattern designs from the early 1890s onwards and they became one of his signature motifs. He drew them in every variety and with stylised simplicity, yet his drawings manage to capture something very lifelike and true to the nature of each species.

The birds that Voysey chose for his bookplate are peacocks, which signify protection, integrity and longevity. Peacocks have been used symbolically in many contexts throughout history and they are often featured in Arts and Crafts designs. A photograph of Voysey's office at his home in St. John's Wood, London (where he lived and worked from 1891 to 1899), shows that he kept a peacock feather on his desk (see Figure 14).

In his manuscript "Symbolism in Design", written in 1930-32, Voysey described the design for this bookplate as representing "the heart felt love of birds, and [the] circle as [a] symbol more desired than possessed".[25] The heart usually represents love and emotions, but when a ring or crown appears around or above it, as in this design, it symbolises self-control, reflecting Voysey's belief that reason must rule the emotions in order to achieve unity and harmony – states of being that he modestly claimed that he strived for rather than actually achieved.

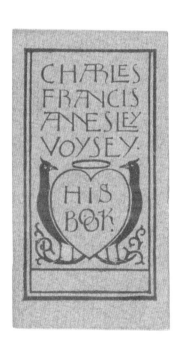

Figure 26
MARY MARIA VOYSEY, after 1906
Drawing in ink on coated linen
21 x 11.8cm (8¼ x 4⅝in.)
(Illustration shown at 90% of actual size)

Created for his wife, Mary Maria, this is the only bookplate in which Voysey illustrated one of the houses he designed. Here he depicted his family home, The Orchard, which he designed at the peak of his career; the ultimate realisation of the complete "Voysey home", it was built in Chorleywood from 1898 to 1899. The Orchard is a modest five-bedroom country cottage set in an idyllic landscape that Voysey wrote about with great fondness, yet it was still convenient for commuting to central London. Furnished with his own designs, it was much published and celebrated at the time of its construction. This bookplate also illustrates Mary Maria holding the couple's young daughter, Priscilla, with sons Charles and Annesley by her side.

Voysey met Mary Maria Evans (1864-?) while he was staying with a friend in the country to recover from an illness. His friend was a master at a preparatory school for boys and Mary Maria was on the staff. They married in 1885 but sadly seem to have had a tense and difficult relationship, perhaps exacerbated in later years by Voysey's poor health. In 1906 they were forced to sell The Orchard due to financial difficulties. The family moved to a rented home in Hampstead, north London, close to Voysey's father and the progressive King Alfred's School, which the children attended (see Figure 110). Eventually Voysey and his wife separated; Mary Maria moved with Priscilla to Welwyn Garden City, while Voysey took a flat in St. James's Street in central London, where he lived alone from 1917 until shortly before his death in 1941.

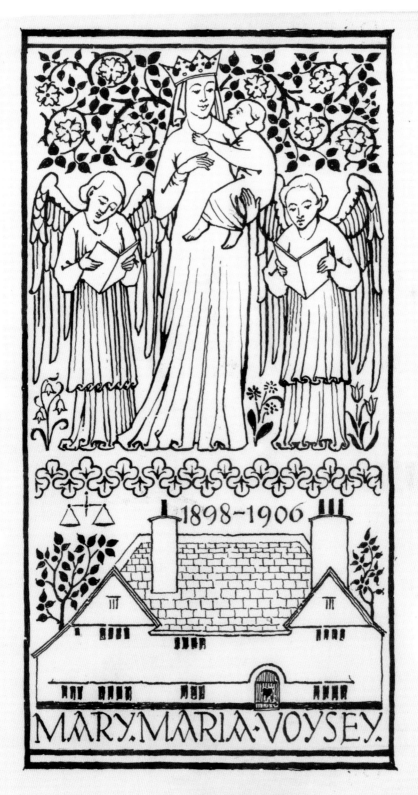

Figure 27
CHARLES VOYSEY, n.d.
Print
11.8 x 7.9cm (4⅝ x 3⅛in.)

These bookplates were designed for Voysey's eldest son, Charles Cowles-Voysey (1889-1981), and his wife, Denise Cowles (1883-1980). The couple married in 1912, at which time he adopted her surname into his own. As a child, Charles was once described in *The Studio* as a "rosy-faced, flaxen-haired lad of four ... the very spirit of design in its native simplicity".[26] In later life, his relationship with his father was distant, but he did choose to follow in his father's footsteps and become an architect. He ran his own practice and was known for being one of the first architects to use concrete honestly, rather than disguised as a traditional building material. Charles undertook a range of work and acted as a consultant for various local authorities, designing town halls, public buildings and houses. His better-known projects include Kingsley Hall, London (1927), a community centre created for the poor of the East End, and Watford Town Hall (1935-40). He was also a keen landscape painter in his spare time. Charles and Denise did not have any children.

Voysey was very interested in both the art of heraldry and his own family history. He owned and studied the standard texts on heraldry, such as the *Manual of Heraldry* (1863) by Charles Boutell and the *Complete Guide to Heraldry* (1909) by Arthur Charles Fox-Davies. The coat of arms featured in these two bookplates is that of the Voysey family. In a 1905 portrait of Voysey, painted by his friend the artist Harold Speed, the architect is shown seated with these arms in the background (see Figure 1). As Voysey wrote, the design derives from "forms of traditional heraldry. The cross of this form is the earliest and the most honourable according to Boutell. The chevron is supposed to represent roof timbers. What the gryphons or eagles heads signify is hard to say. The sea-horse was doubtless to indicate that the owners were originally pirates [*sic*]".[27] The Latin motto "Sub hoc signo vinces" is the Vaizey family motto (also used by the Voyseys) and means "Under this sign we shall conquer".

The Voysey Family

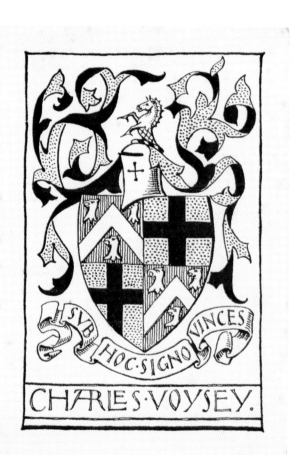

SVB HOC·SIGNO VINCES

CHÆRLES·VOYSEY.

Figure 28
DENISE AND CHARLES COWLES-VOYSEY, n.d.
Print
11.8 x 8cm (4⅝ x 3⅛in.)

The Voysey Family

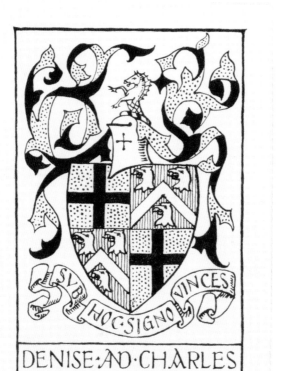

SVB HOC SIGNO VINCES

DENISE·AND·CHARLES
COWLES·VOYSEY

Figure 29
DENISE COWLES, n.d.
Print
11.1 x 7.6cm (4⅜ x 3in.)

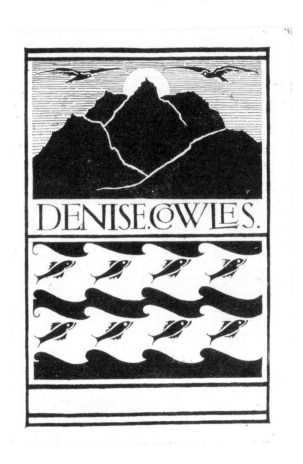

In 1912 Denise Cowles married Voysey's eldest son, the architect Charles Cowles-Voysey. This bold design, made by Voysey for his daughter-in-law, was intended, as he wrote, to suggest "a love of flight o'er land and sea".[28] The Crab Tree Farm album contains duplicates or alternative prints of some bookplates. All have been included for completeness.

The Voysey Family

Figure 30
DENISE COWLES, n.d.
Print
10 x 6.5cm (3¹⁵⁄₁₆ x 2%₁₆in.)

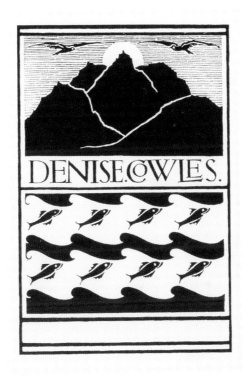

Figure 31
PRISCILLA MARY ANNESLEY VOYSEY, n.d.
Print
8.9 x 4.2cm (3½ x 1⅝in.)

This bookplate contains a loving portrait of Voysey's daughter, Priscilla (1895-?), and was described by the designer as "a bookplate designed for a little girl whose standard was faithfulness and constancy, as suggested by the wild flowers of the field and the swallows that return year by year".[29] The stylised, two-dimensional treatment of birds and flowers in this bookplate is characteristic of Voysey's flat pattern designs and is repeated in a number of his works.

Priscilla Voysey was born in London in October 1895 and appears as a young child in the bookplate that Voysey made for her mother (see Figure 26). She was close to both her parents and she continued to live with her mother in Welwyn Garden City after they separated in 1917.

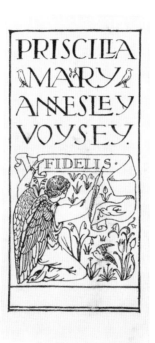

PRISCILLA MARY ANNESLEY VOYSEY

FIDELIS·

Figure 32
ANNESLEY VOYSEY, n.d.
Print
Diameter 8.3cm (3¼in.)

Voysey wrote that "Annesley Voysey's bookplate is the old and never to be forgotten symbol of self-sacrificing love. The pelican plucking its breast to feed its young".[30] Annesley (1893-1971) was the youngest of the Voysey children. He was a naturalist and author, and married Phyllis Fenton in 1921 (see Figure 33).

This is the most common form of the bookplate that Voysey designed. There are twenty bookplates or letterhead designs in the Crab Tree Farm album that take the shape of a roundel, with a band of lettering separated by crosses and a pictorial design in the centre. One of these examples features a variation on the design of a pelican feeding its young, accompanied by the motto "Semper fidelis", meaning "Always faithful" (see Figure 143).

Figure 33
PHYLLIS ELIZABETH AND ANNESLEY VOYSEY, c.1923
Drawing in ink on Japanese vellum
15.2 x 14.6cm (6 x 5¾in.)
(Illustration shown at 90% of actual size)

Voysey's youngest son, Annesley (see Figure 32), married Phyllis Elizabeth Fenton (1899-1972) in September 1921. This is a joint bookplate made for the couple, who had two children: a daughter, Elizabeth Annesley, born in 1927; and a son, John Conway, born in 1929.

One of twenty round bookplates in the Crab Tree Farm album, this design includes an owl (representing wisdom), a squirrel, a dove (love) in an olive tree (peace) and a rabbit amongst flowers on a grassy mound. Voysey also used the same design for Margaret Barlow's bookplate (see Figure 102). This is one of only a small number of bookplates in the Crab Tree Farm album that are dated. The page is signed by Voysey, with his address in St. James's Street and the date 13 June 1923.

The Voysey Family

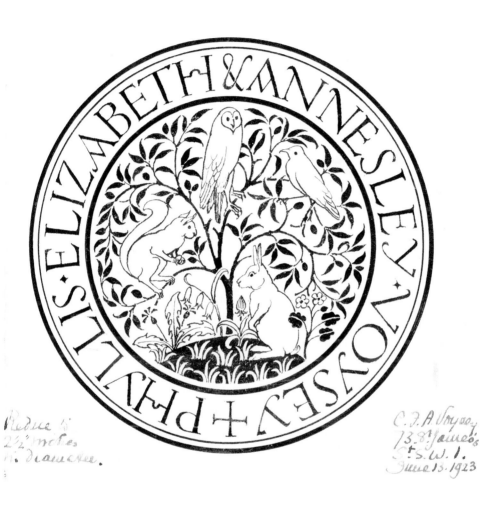

ELIZABETH & ANNESLEY · VOYSEY + PHYLLIS ·

Figure 34
MARGARET ANNESLEY ADVANI, n.d.
Print
9.8 x 7.1cm (3⅞ x 2¹³⁄₁₆in.)

In this bookplate, the heart symbolises love; above it is an English rose and on either side four swallows, representing faithfulness and constancy, fly away. It was designed for Margaret Annesley Voysey (1858-?), Voysey's sister. Margaret married Motiram S. Advani, which Voysey recorded on the family tree that he drew around 1935 (now in the RIBA Archives).

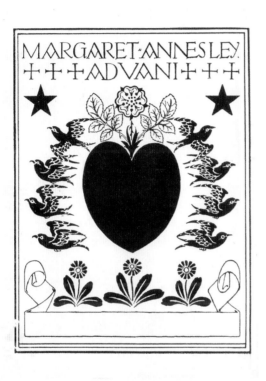

MARGARET·ANNESLEY.
✝ ✝ ✝ AD·VANI ✝ ✝ ✝

Figure 35
ELLISON ANNESLEY VOYSEY, n.d.
Print
11 x 6.1cm (4⁵⁄₁₆ x 2⁷⁄₁₆in.)

Ellison Annesley Voysey (1867-1942) was Voysey's youngest brother and a good friend. He followed in their father's footsteps and became a minister of the Theistic Church. Ellison married Rachel Enthoven (1861-1912), of The Hague, in 1898 and they had one daughter, Ella (see Figure 39), who became an actress. Voysey wrote of this bookplate:

> This design is intended to denote the large-hearted, faithful and generous character to which the owner aspires. The grape or fruitful vine that cheers the heart of man is on one side and on the other the olive, being the symbol of the peacemaker, holds out, or that which produces oil for the troubled waters. The cross is used as a symbol of faith, not necessarily Christian. The heart crowned is the heart controlled. As before stated the heart in its earliest inception denoted self-control. The band round the head shewing [*sic*] that the head was controlled. In early times this quality of self-control was regarded as the first essential of Kingship, as no-one could wisely control others who was not controlled himself.[31]

The design was published in *The Builder* to illustrate the lecture "Modern Symbolism", which Voysey gave at Carpenters' Hall, London, in 1918.

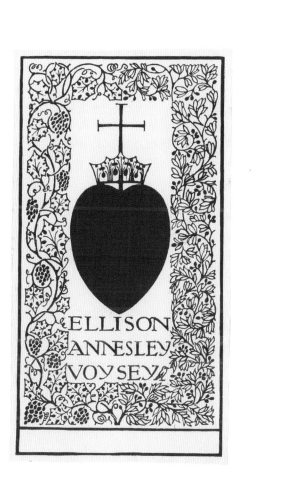

ELLISON
ANNESLEY
VOYSEY

Figure 36
ELLISON ANNESLEY VOYSEY, n.d.
Print
11.6 x 6.5cm (4½ x 2¾₆in.)

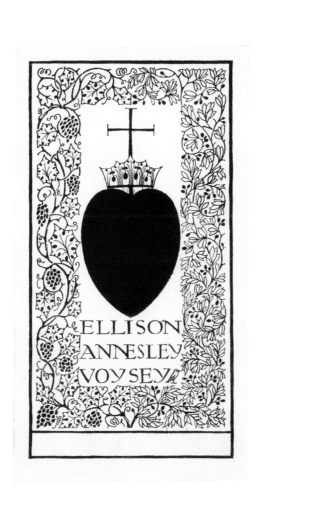

ELLISON
ANNESLEY
VOYSEY

Figure 37
RACHEL VOYSEY, n.d.
Print
8.7 x 9.3cm (3⁷⁄₁₆ x 3¹¹⁄₁₆in.)

Voysey created a pictorial portrait of his sister-in-law, Rachel Voysey, in her bookplate, using a combination of images and symbols to suggest her character: "This bookplate was for a very musical lady (now deceased) for whom the angels blew and the organ sang. Her quiver is full of darts, shewing [*sic*] she was quick to loving impulse and she had a heart that was clinging as ivy and a merry wit was always in attendance in the corner".[32]

Rachel Voysey (née Enthoven) was born in The Hague in 1861. She married Voysey's brother, Ellison Annesley Voysey (see Figure 36) on 15 June 1898. They had one daughter, Ella (see Figure 39). Rachel died in Birmingham in November 1912, predeceasing her husband by thirty years.

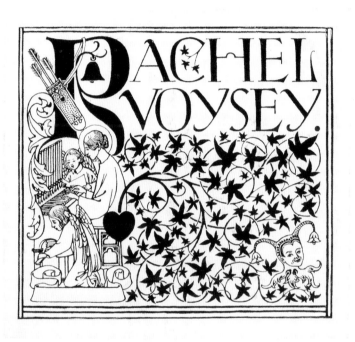

Figure 38
JOAN MARY NAOME VOYSEY, n.d.
Print
8.7 x 10.9cm (3⁷⁄₁₆ x 4⁵⁄₁₆in.)

Voysey made this bookplate for Joan Mary Naome, the second wife of his brother, Ellison (see Figure 35) The designer described the bookplate and its owner as:

> ...of English and Irish descent, hence the rose and shamrock are intermingled. The angel enthroned above the symbol of cloud, with harp, denotes the musical nature of the owner and the halcyon that faithful, patient bird that stills the raging of the seas, giving us halcyon days, suggests a peaceful nature.[33]

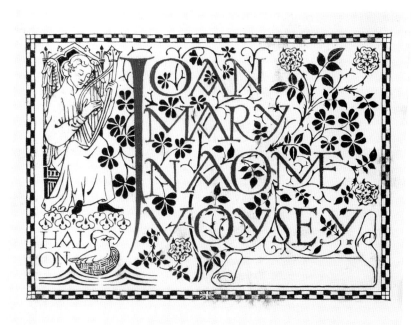

JOAN MARY NAOME VOYSEY HALCYON

Figure 39
ELLA ANNESLEY VOYSEY, n.d.
Print
Diameter 7.3cm (2⅞in.)

This round bookplate exhibits one of Voysey's standard formats. It includes the name of his niece, Ella, with three hearts "linked together [symbolising] Father, Mother and Daughter".[34] In the centre is a swallow, which represents faithfulness and constancy.

Ella Annesley Voysey (1902-?) was Voysey's niece, the daughter of his youngest brother, Ellison, and his first wife, Rachel (see Figures 35 and 37). Ella was close to her uncle, who delighted in her company; indeed, she made him "beam all over with happiness and contentment".[35] Despite her nonconformist upbringing and her uncle's disapproval of theatre and cinema, Ella became an actress and married Robert Donat (see Figure 40), one of Hollywood's most famous stars of the 1930s and 1940s. She met her future husband while taking piano lessons with a teacher who lived on the same road as the Donat family in Manchester and she acted alongside him at the Festival Theatre in Cambridge. They married in August 1929 in the Presbyterian Meeting House at Dean Row, near Wilmslow, Cheshire. The couple lived comfortably in Hampstead and Buckinghamshire.

The Donats had three children, Joanna (1931-), John Annesley (1934-) and Brian (1936-). In 1940 Ella took the children to the United States for safety during World War II. She visited her husband's family in Connecticut and then settled for a time in Beverly Hills, California. By the time she returned to England in July 1945, she and her husband had grown apart and they divorced in 1946. Their daughter, Joanna, married in 1954; John became an architectural photographer and Brian emigrated to Canada, where he made a career in publishing.

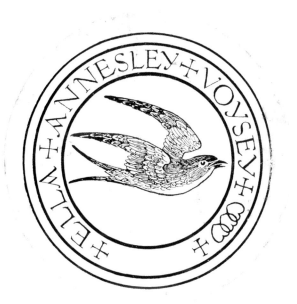

✠ ELLA ✠ ANNESLEY ✠ VOYSEY ✠

Figure 40
ROBERT DONAT, after 1929
Print
10.8 x 7.3cm (4¼ x 2⅞in.)

This bookplate was designed for an actor "who carried merry thought wherever he went. Honesty and affection for E.D. filled his sails".[36] The actor in question was Robert Donat (1905-1958), the noted film and stage actor who married Voysey's niece, Ella, in 1929. Donat was born and raised in Manchester, where he met Ella (see Figure 39). Described by actor and director Charles Laughton as "the most graceful actor of our time", Donat found success on both the British stage and the Hollywood big screen.[37] His most memorable parts were in Alfred Hitchcock's *39 Steps* (1935) and *Goodbye, Mr. Chips* (1939), for which he won an Oscar for best actor. The couple had three children but divorced in 1946. In 1953 Robert married the British actress Renée Asherson (1920-).

Although he disapproved of film and theatre, Voysey was extremely fond of his niece and her husband, whom he saw regularly in London; he occasionally designed greetings cards for them (see Figure 146). Following Voysey's death, Donat broadcast and published a very personal and affectionate tribute to his unique uncle Charles.[38]

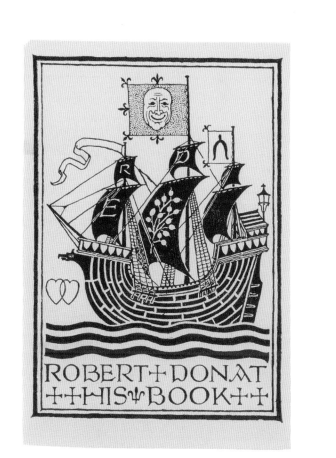

ROBERT✝DONAT
✝✝HIS✞BOOK✝✝

Clients and Their Families

Figure 41
ARCHDEACON JOHN TETLEY ROWE, 1908
Print
8.5 x 7.3cm (3⅚₆ x 2⅞in.)

In 1908 Voysey was commissioned by Archdeacon John Tetley Rowe (c.1860-1915) to undertake additions and alterations to The Precinct, in Rochester, Kent. Apparently no drawings or details related to the commission survive, but Voysey's office expenses suggest that some work was carried out.[39] Voysey also designed a magazine cover for the archdeacon's parish.

Because of its shape, the form of this bookplate is known as a *vesica*. The shield with the Saint Andrew's cross and a shell is copied from the armorial of the Diocese of Rochester. The Paschal Lamb is a Christian symbol, also used in heraldry to represent faith, gentleness, purity and bravery. Voysey often used the fleur-de-lis background to symbolise purity. A variation of this design, which was used as the archdeacon's seal, was included in Voysey's "Symbolism in Design"; he described it as "Archdeacon Rowe's archidiaconal seal, being the arms of the See of Rochester. The Cathedral, being originally dedicated to St. Andrew, bears the Saint's cross on its shield".[40] This alternative design is simpler than the example in the Crab Tree Farm album. The shield and cross are set against a plain background; above is the date A.D. 1908.

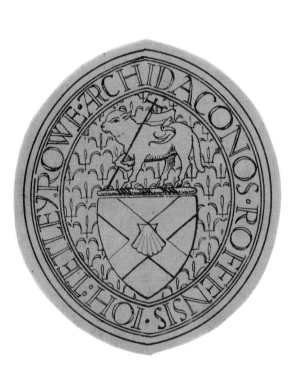

Figure 42
HELEN BRIGGS, after 1898
Print
11.9 x 7.5cm (4¹¹⁄₁₆ x 2¹⁵⁄₁₆in.)

Helen Briggs (née Jones, 1860-1938) was the wife of Arthur Currer Briggs (1855-1906), who commissioned Broadleys, the couple's country home, from Voysey in 1898. Briggs was a colliery owner and he took over the family business at age twenty-five, after his father's sudden death in 1881. He lived in Leeds and served as lord mayor from 1903 to 1904 (Voysey designed the invitation to a reception held by the mayor in 1904). Helen and Arthur Briggs married in 1883 and they had three children: Dorothy (1884-1956), Reginald Martin (1891-1947) and Donald Henry (1893-1974).

Broadleys was one of Voysey's most significant and successful commissions. Modest in size, this idyllic country retreat took full advantage of the spectacular views over Windermere. In 1904 it was published in Hermann Muthesius's *Das Englische Haus*, in which the author noted that Broadleys was "built and designed throughout by C.F.A. Voysey", one of "the most individualistic of the busy domestic architects in London today".[41]

This simple design for a bookplate, with stylised seed heads from the common honesty plant, was printed in both green and purple. As was often the case, Voysey's design attempts to capture the character of its owner. He wrote of his choice of motif, "This denotes honesty which is the first cousin of sincerity and parent of many virtues."[42] This description and the bookplate's design suggest the designer's open relationship with an important client and his family, developed over a number of years.

Clients and Their Families

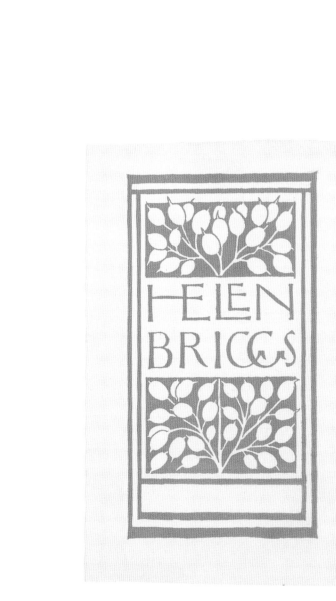

Figure 43
HELEN BRIGGS, after 1898
Print
11.9 x 7.5cm (4¹¹⁄₁₆ x 2¹⁵⁄₁₆in.)

Clients and Their Families

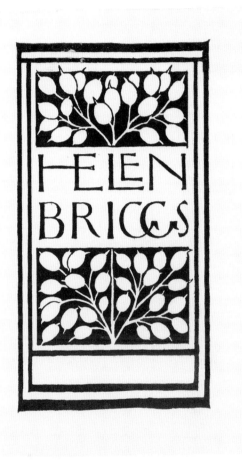

Figure 44
LILY MAUD AND CHARLES STEWART KING, 1899
Print
7.9 x 13cm (3⅛ x 6⅛in.)

This is one of two bookplates designed by Voysey for the same client (see Figure 45). In 1899 he undertook alterations and additions to Dollis Brae, a house in Totteridge, Barnet, London, for the solicitor Charles Stewart King and his wife, Lily Maud. The couple married in September of that year and it is likely that Voysey designed this bookplate to mark the occasion. The Kings were among Voysey's many repeat clients and he did further work on their house in 1902-03, also designing a veranda seat for them. The architect wrote a long explanation on the symbolism of this bookplate:

> The mark of man and his wife bound together by the birds of the air: the crown for kingly qualities is used, as the name was no doubt given for the same in ages past. Birds! Why birds? Some may enquire. Surely the answer is, that thoughts and things from the heavens are nearer the spirit than the flesh. Ideas and feelings are fleeting. Do we not say "on the wing"? The sequence of association is so strong, that the heavenly blue in the sky makes us invest our angels with wings and in time we regard the dove as the symbol of the Holy Spirit. When we contemplate the eagle, even in captivity, in the Zoological Gardens, how can we resist a feeling, a reverent admiration for his superb dignity, and contemplative grandeur. Not only for his far sight, but for his nobility, is the eagle the aristocrat of birds, and their premier peer. As we look up to the noble and the Godlike, so also we aspire.
>
> We rise in contradistinction to the worm and the grovelling materialist. Association of ideas is forever working in two directions, up and down, above and below, light and darkness. And so on all through human experience we measure values by comparison and hence it is that we aspire and seek the blue heavens for more light.[43]

Clients and Their Families

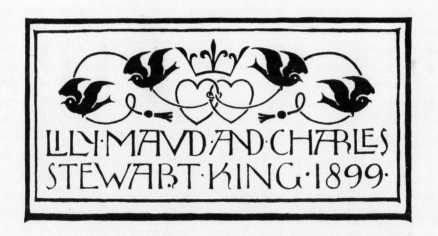

LILLY·MAUD·AND·CHARLES
STEWART·T·KING·1899·

Figure 45
CHARLES STEWART KING, n.d.
Print
10.8 x 5.2cm (4¼ x 2¹⁄₁₆in.)

The second of two bookplates designed for Charles Stewart King uses a combination of Voysey's favourite symbols – a heart and crown, the scales of justice and an olive tree – to create a picture portrait of the bookplate's owner. Writing in 1932, he explained that "the late Charles Stewart King was a solicitor. A big heart nourishes the roots of the olive tree. The oil of olive should be the ink of lawyers, stilling the troubled waters; or saving us from conflict. The scales of justice are engraved upon his heart".[44]

Clients and Their Families

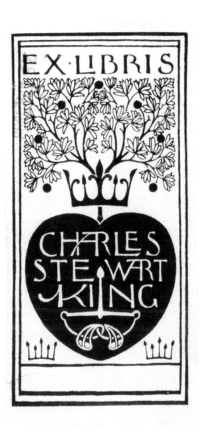

EX·LIBRIS

CHARLES
STEWART
KING

Figure 46
BEATRICE EMILY AND JAMES MORTON, 1901
Print
12.4 x 5.7cm (4⅞ x 2¼in.)

In "Symbolism in Design" Voysey identified this design as "the joint book plate of Beatrice Emily and James Morton. The lady is of Irish descent, while her husband hails from Scotland, hence the thistle and the shamrock are growing together, whilst birds stand sentry over the united hearts".[45]

Beatrice and James Morton (1867-1943) were an artistic couple who shared ideas about fine craftsmanship, politics and patronage of the arts. They surrounded themselves with the latest art and furnishings of the day, much of which was designed or made by artists and craftsmen who became their close friends. This bookplate commemorates their wedding, on 21 March 1901. The pair of interlocking hearts, which represents the Mortons' union, is a symbolic device often found in Voysey's pattern designs.

James was the son of Alexander Morton, who founded the textile manufacturing company Alexander Morton & Co. in Ayrshire in 1870. In 1895 James became a partner in the firm, transforming production by commissioning designs from some of the country's most avant-garde designers. The most important and long-lasting relationship he forged was with Voysey, with whom he worked closely. In 1896 Voysey's first designs for Alexander Morton & Co. were exhibited at the Arts and Crafts Exhibition in London; the next year he signed an unusual five-year, renewable contract to produce a minimum of ten exclusive designs annually for the sum of £120. This arrangement lasted for about ten years, during which Voysey produced as many as forty designs a year. By this time James had also set up Morton Sundour, a branch of the company that specialised in producing fabrics with fade-proof dyes. Voysey's fresh, modern decorative patterns for the company were extremely successful; they were sold through Liberty and Morris & Co. in London and Wylie and Lochhead in Glasgow. Voysey also designed many advertisements and badges for Alexander Morton & Co.

Clients and Their Families

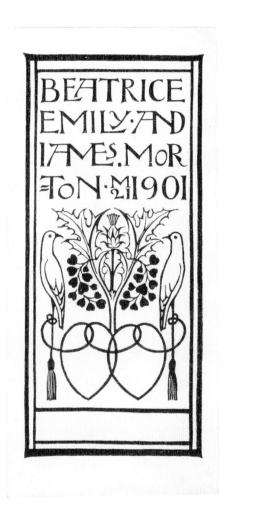

Figure 47
P.A B.E BARENDT, 1900-10
Print
9.2 x 7.3cm (3⅝ x 2⅞in.)

Philip Arthur Barendt (1865-?) was an insurance manager with his own business in central London. He and his wife, Emma Beryl (1868-?), had one daughter, Beryl (see Figure 48). Voysey undertook a variety of additions and alterations to the couple's Hampstead home between 1901 and 1909, also designing furniture and decorations for it. The Barendts later moved to St. Margaret's-at-Cliffe, Kent, where Voysey redesigned a bungalow to create a two-storey home for them.

Voysey described this bookplate as "designed to suggest generosity, by the fruitful vine, industriousness, by the busy bee, and beneficence, by the heart crowned with a coronet of roses. It is the joint property of husband and wife, and the qualities suggested by it are the mainspring of the family character".[46]

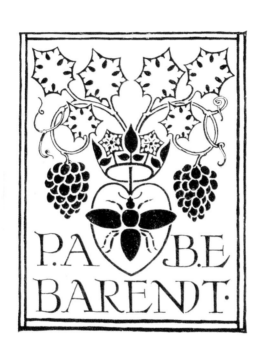

Figure 48
BERYL BARENDT, n.d.
Print
9.8 x 7cm (3⅞ x 2¾in.)

"Beryl Barendt, the owner of this design", wrote Voysey, "is a trained Red Cross worker, much attached to the Navy, hence the symbol of a battleship in the angel's hand. The busy bee suggests the two initials of the lady, as well as her industry".[47]

Beryl Barendt was the daughter of Voysey's clients Philip Arthur and Emma Beryl Barendt, for whom he also designed a bookplate (see Figure 47). She is listed under several London addresses in Voysey's address book, latterly as Mrs. Campbell Jones.

Clients and Their Families

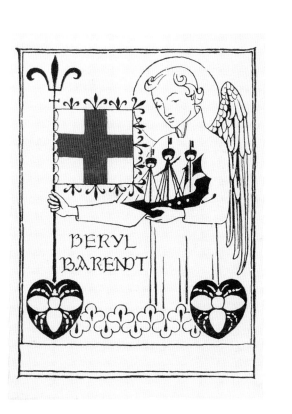

BERYL
BARENDT

Figure 49
RICHARD WALTER ESSEX, after 1897
Print, top and bottom borders cancelled by hand in ink
12.7 x 10.2cm (5 x 4in.)

This bookplate displays the characteristics of some of Voysey's earliest pattern designs. These fluid, organic designs were particularly influential on the development of Art Nouveau in Europe, where they were known through journals such as *Dekorative Kunst*.

Richard Walter Essex founded Essex & Co., a specialist wallpaper-printing firm in London, in 1897. From the company's earliest days, Essex formed a strong alliance with Voysey, commissioning him to design wallpaper for Essex & Co., which quickly became such a success that Voysey's name became synonymous with the company. By the 1920s Essex & Co. was describing him in its advertisements as "The Genius of Pattern".

In addition to wallpaper, Voysey designed advertisements, furniture and shop interiors for Essex & Co. Essex was also one of Voysey's earliest architectural clients and a close friend. He commissioned his house, Dixcot, in Tooting Bec, south London, from Voysey in 1897. The designs for the house appeared in a number of journals, but disagreements between Voysey and Essex (or rather, it is said, Mrs. Essex) caused him to abandon the design. A revised version was then built under the supervision of the architect Walter Cave.

Clients and Their Families

RICHARD · WALTER · ESSEX

HIS · BOOK

Figure 50
DOROTHY À BECKETT TERRELL, 1915
Print
11.3 x 6.5cm (4⁷⁄₁₆ x 2⁹⁄₁₆in.)

Dorothy À Beckett Terrell (1879-?) was the daughter of Arthur À Beckett Terrell (see Figure 51), a client and friend of Voysey. She wrote books for girls, including *Sister-in Chief* (1912) and *Last Year's Nest* (1925).
In "Symbolism in Design" Voysey described this bookplate:

> [It] was made for a maiden lady and authoress who lived in a castle in the air, at the base of which we have the Gothic symbol of the cloud. Above are the books making the foundation of the castle. The port cullis is down and flowers are growing in the way, showing there is little or no traffic to the castle, but nevertheless, sweet sounds come from the castle battlements, and the banner is emblazoned with the emblem of love and sympathy.[48]

A note in Voysey's ledger of professional expenses for the years 1906-40 records the sum of seven shillings and six pence paid for materials related to the "Bookplate for Miss Terrell" on 29 January 1915.

Clients and Their Families

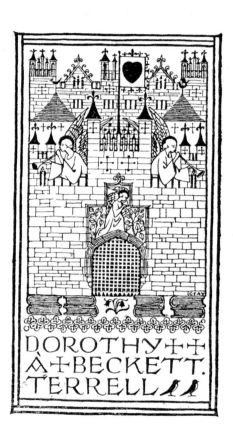

DOROTHY † †
À † BECKETT.
TERRELL

Figure 51
ARTHUR À BECKETT TERRELL, 1917
Print
19.1 x 12.7cm (7½ x 5in.)

The preliminary sketch for this bookplate for Arthur À Beckett Terrell, an eminent lawyer and one of Voysey's clients, is in the collection of the RIBA (Figure 23). It was designed in 1917 and there are three entries in Voysey's ledger of professional expenses for February of that year. The design was published in Voysey's 1918 and 1929 articles on "Modern Symbolism" in *The Builder*. In the sketch Voysey worked out the broad structure of the symbolism, which was based on the idea of a family tree. On the reverse, he wrote out a key to each symbol, which he also expanded on in his "Symbolism in Design":

> Again we have the oak of sturdy growth and the heart signifying the emotions and affections. The crown or band which is usually placed around the head is the original symbol of self control, indicating the fact that the mind (that is, reason) must control the emotions. Hence its position in this design around the heart. The crown itself is composed of fleur-de-lis which stands for purity. The flame signifies the soul, flame being one of the most indefinite forms in the world of matter, seems on that account a suitable symbol, and it is also a warming and purifying medium. It is placed at the centre of growth and at the base of it, as literally it is at the heart and core of all things. The proportional compasses symbolise logic, given a dimension at one end, the natural sequence logically follows at the other. The lantern or light that is caged in and confined by the material body, denotes psychology, namely the inward light that gives understanding. The egg is the symbol of "form" being the universal beginning of all animal life. The scales stand for law and justice. The spade is the sign of economics, it is the instrument by which material is made to fructify. The white heart stands for ethic, or virtue, ethical thought depending more on fuel than on feeling than on reason. The human hand grasping the old familiar sign of the Divine, denotes religion. The essence of religion being the conscious relation of the creature to its Creator. The eagle which is the highest flyer and the furthest seer stands for aspiration, and revelation, the heavenward quest, which in other words, is true philosophy and constitutes the chief interest of the late owner of this book-plate, and who was a barrister as well as a philosophic writer.[49]

À Beckett Terrell (1843-?) and his wife, Georgina Frederick (1856-?), lived in London and Ashmansworth, Hampshire. Their daughter, Dorothy (1879-?), wrote books for girls (see Figure 50). Their son, Claud Romako, died in World War I at the age of thirty-three.

Clients and Their Families

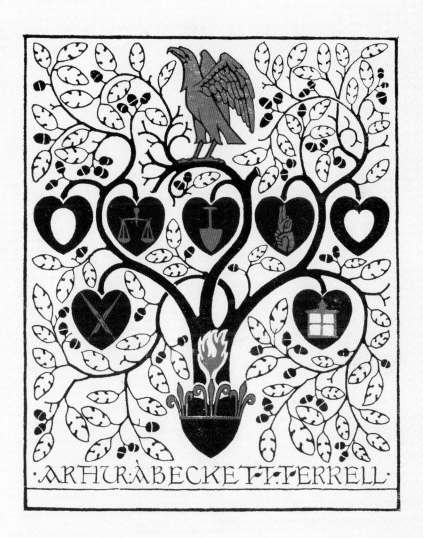

·ARTUR·À·BECKETT·TERRELL·

Figure 52
WILLIAM SINGER BARCLAY, 1917
Print
7.9 x 6.8cm (3⅛ x 2¹¹⁄₁₆in.)

Designed by Voysey for his client William Singer Barclay, "this bookplate represents the old ship *Antelope* which was made famous in its day by the Captain who was the ancestor of the owner of this plate; in the left-hand corner will be the symbol denoting tenacity and friendship".[50]

The symbol of the heart and hand appears on one other bookplate (see Figure 119) and a version in carved wood can also be seen in a photograph of Voysey at the exhibition of his work at the Batsford Gallery, London, in 1931 (see Figure 24). An alternative to this design is in the drawings collection at the RIBA; it includes a train crossing a bridge and symbols such as a clock, spade, sword, and hand holding a heart.[51]

Voysey designed some furniture and carried out alterations and additions to Barclay's house in Bayswater, London, in 1915. He noted in his address book that Barclay was a "Friend of [the] Barendts" (see Figure 47). Voysey's ledger of professional expenses records that he bought Whatman paper for this bookplate on 30 March 1917.

Clients and Their Families

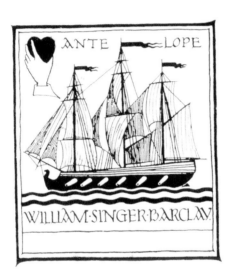

Figure 53
CHARLES THOMAS AND NANCY BURKE, c.1905
Drawing in ink
9.5 x 7.1cm (3¾ x 2¹³⁄₁₄in.)

Charles Burke, a company secretary, and his wife, Nancy, were among the small number of clients who were able to commission Voysey to design not just a house, but also all its furnishings and fittings. Following a visit to Voysey's home, The Orchard (see Figure 16), in 1905, the Burkes asked him to design Holly Mount, which was to be their second home, on a large plot in Beaconsfield, Buckinghamshire. Photographs of the house and its interiors were published in English and German journals, helping to consolidate Voysey's reputation as an accomplished and fashionable designer of the complete home.

Voysey described the motifs he used in this bookplate in "Symbolism in Design".[52] Each symbol stands for an aspect of his clients' characters. The streak of lighting represents quickness of perception, while the scales illustrate a sense of justice. The bee denotes the first initial of their surname and the honesty plant, the shamrock and the Irish shillelaghs indicate the owners' nationality.

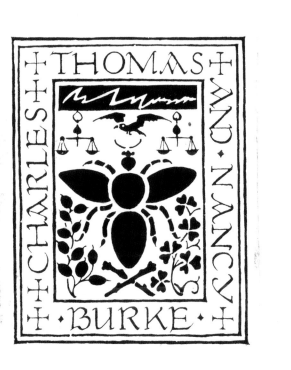

Figure 54
CHARLES THOMAS AND NANCY BURKE, c.1905
Print
10.7 x 8.8cm (4³⁄₁₆ x 3½in.)

Clients and Their Families

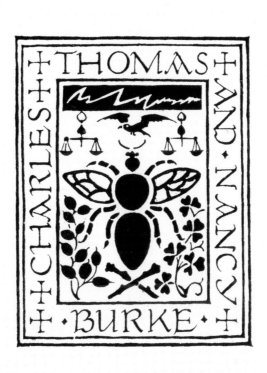

THOMAS AND NANCY CHARLES BURKE

Figure 55
HENRY VAN GRUISEN, c.1905
Print
8 x 8cm (3³⁄₁₆ x 3³⁄₁₆in.)

Henry van Gruisen was a fruit merchant who lived at 37 Bidston Street, Birkenhead, with his wife, Frances, and their three children. In 1902 and 1905 Voysey undertook alterations and designed furniture for their home. The drawings for his designs were exhibited at the Arts and Crafts Exhibition of 1903, published in *Dekorative Kunst* and reviewed by the German architectural critic Hermann Muthesius. Van Gruisen also commissioned Voysey to make additions and alterations to and provide a garden design for a new home at Hambledon Hurst, The Green, Hambledon, in 1919.

This bookplate incorporates the mythical halcyon bird, one of the most distinctive birds of Voysey's lexicon:

The halcyon bird, [was] fabled by the ancients to breed in [a] floating nest on sea at winter solstice and to charm wind and waves into calm. So used to denote a calm and placid nature. Dr. William B. Carpenter in his book "Principles of Mental Physiology" page 490 says: "The constructive imagination is more characteristically exercised in the elaboration of some work which consists of a methodical aggregation of separate images, that are grouped round what may be termed a central idea".

"Fancy" says Wordsworth, "is given to quicken and beguile the temporal part of our nature; imagination to incite and support the eternal".[53]

Clients and Their Families

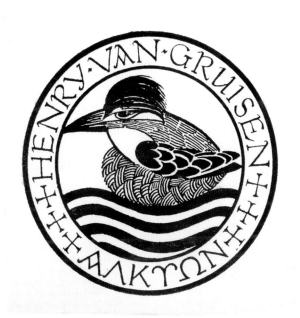

Figure 56
LAURENCE IVAN AND LUCY HORNIMAN, 1923
Print
Diameter 7.9cm (3⅛in.)

From the earliest known examples, bookplate imagery has played on the name of the owner; this plate for a husband and wife falls into that tradition. Voysey wrote, "Laurence and Lucy Horniman (Barrister) upon the horn beside the hornbeam tree and the hornbeam bird, the scales and wig of the barrister. L.I.H. upon the coat of the servant. In the middle ages a play on names was not uncommon".[54] Voysey's ledger of professional expenses records expenditures of two pence related to this design, paid on 8 June 1923.

The Hornimans – lifelong friends and clients of Voysey – were great advocates of Arts and Crafts principles. Voysey designed and remodelled homes, designed furniture and planned a public garden for E.J. Horniman. Frederick Horniman founded The Horniman Museum in Forest Hill, designed by Voysey's friend, Charles Harrison Townsend.

Clients and Their Families

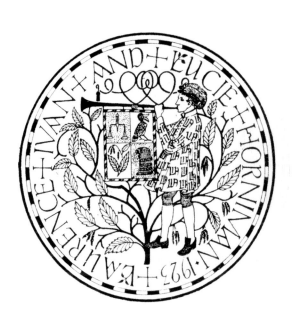

Figure 57
PERCY HEFFER, 1897-1902
Print
12.4 x 11.8cm (4⅞ x 4⅝in.)

Percy Heffer was one of Voysey's early clients, commissioning him in 1897 to design a veranda for his home in Brondesbury, an area of Kilburn in north London. In 1902 he asked the architect to design a new stable and gates for Heathdene in Watford, Hertfordshire. Heffer was "descended from a famous coach builder and became a barrister, hence the scales and proportional compasses".[55]

Clients and Their Families

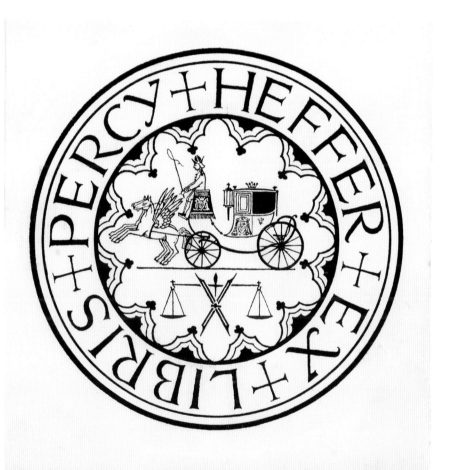

Friends and Individuals:
Architects and Associates

Figure 58
ANDREW NOBLE PRENTICE, n.d.
Print
Diameter 6.7cm (2⅝in.)

Voysey's interest in heraldry led him to design several bookplates in the armorial style. Discussing this bookplate, which has the motto "Tenax propositi", meaning "Firm of purpose", Voysey noted that the traditional heraldic motifs, including a wolf's head as a crest, were "throwing no light on the owner's character or aspirations".[56]

Andrew Noble Prentice (1866-1941) was a Scottish architect whom Voysey knew through the RIBA and the Arts Club. They also served together on the board of the Imperial Arts League (see Figure 126). Like Leonard Rome Guthrie (see Figure 59), Prentice was educated in Glasgow and articled to William Leiper, the architect of Glasgow's iconic Templeton's Carpet Factory (1889-92). He set up his own practice in London in 1891 and became a fellow of the RIBA in 1902. He made his name by travelling and publishing the book *Renaissance Architecture and Ornament in Spain* in 1893. Although he is not one of the best-known architects of the period, he built a number of fine Arts and Crafts houses in Gloucestershire and Worcestershire and his work was featured, along with Voysey's, in Hermann Muthesius's seminal book on British domestic architecture, *Das Englische Haus*. His most famous building is the Examination Hall of the Colleges of Surgeons and Physicians, Queens Square, London. He also designed the interiors of steamships on Australian and South American lines.

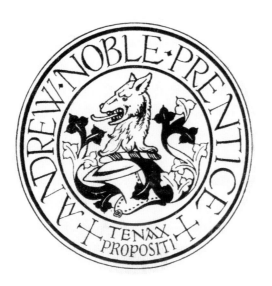

Figure 59
LEONARD ROME GUTHRIE, 1929
Print
8.6 x 4.9cm (3⅜ x 1¹⁵⁄₁₆in.)

This rectangular bookplate features a typical combination of a heart and vine, along with the motto "From the heart springs the fruitful vine". Although Voysey noted that this was a "rejected design", he explained that it "was intended to suggest genial hospitality and generosity".[57] This bookplate is signed "C.F.A. V" and dated 1929.

Leonard Rome Guthrie (1880-1958) was an architect and friend of Voysey and fellow Scot Andrew Noble Prentice (see Figure 58). He trained in the Glasgow office of William Leiper from 1895 to 1900, during which time he also studied at the Glasgow School of Art. After travelling on a scholarship, he married and established his own practice in London in 1907. In 1925 Guthrie became a partner in the firm of Wimperis, Simpson and Guthrie and the same year he was elected a member of the Art Workers Guild and a fellow of the RIBA. Notable among his work was the rebuilding of Winfield House in Regent's Park, London (1937), which became the residence of the American ambassador. He also designed office blocks and public buildings, including transmitting stations and the Mill Hill Observatory, and was architect to the Royal Institution beginning in 1913.

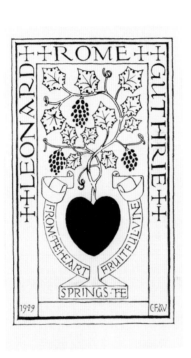

+LEONARD+ +ROME+ +GUTHRIE+

FROM THE HEART FRUITFUL VINE

SPRINGS THE

1922 CFA V

Figure 60
ARNOLD MITCHELL, n.d.
Print
10.8 x 7.3cm (4¼ x 2⅞in.)

This bookplate design is an adaptation of the Mitchell coat of arms, to which Voysey added three birds (a robin and two blackbirds) and the motto "A little less talk and a little more play".

Arnold Mitchell (1863-1944) was an architect and friend of Voysey. They were both fellows of the RIBA and long-serving members of the Arts Club. Mitchell is not a particularly well-known Arts and Crafts architect, but he ran a large and successful practice in London. Like Voysey and others in their circle, his architectural work was featured in Hermann Muthesius's *Das Englische Haus*, as well as in other architectural journals and publications of the day. Many of the houses he designed are located in and around Harrow, north London. Mitchell also developed a reputation internationally, with commissions in Argentina, Austria and Belgium. Following Voysey's death in 1941, Mitchell wrote a letter of sympathy to his son, Charles Cowles-Voysey, describing the older architect as having been "full of years and honour".[58]

A little less talk &
a little more play.

ARNOLD·MITCHELL

Figure 61
GEORGE BRUCE GOSLING MDCCCCXV, 1915
Print
8.2 x 5.5cm (3¼ x 2⁵⁄₁₆in.)

Voysey called this "the bookplate of an Architect and author of the garden herein shown. The fleur-de-lis is part of the owner's traditional crest. St. George is his patron saint and the vision form is intended as an allusion to his ecclesiastical sympathies".[59] This is one of only two bookplate designs in the Crab Tree Farm album that feature architecture (the other is the bookplate designed by Voysey for his wife, which illustrates their home, The Orchard – see Figure 26). Although Voysey described it as a bookplate for an architect, George Bruce Gosling was not formally registered as a trained architect in the records of the RIBA.

Figure 62
GEORGE BRUCE GOSLING MDCCCCXV, 1915
Print
9 x 5.3cm (3⁹⁄₁₆ x 2¹⁄₁₆in.)

Architects and Associates

Figure 63
ROBERT HEYWOOD AND
MARGARET DOLORES HASLAM, n.d.
Halftone print
11.8 x 8.2cm (4⅝ x 3¼in.)

This bookplate displays an adaptation of the traditional Haslam coat of arms. Voysey altered the colourway from red to green and added a squirrel and some hazelnuts in place of a hazel tree and four leaves, perhaps referring to the Anglo-Saxon origins of the family name, which derived from the village of Haslam (meaning "hazelwood") in Lancashire. The motto he added at the bottom edge, "Honeste vivo", means "I live honestly".

Robert Heywood Haslam was a trainee architect in Voysey's office from 1895 to 1897, signing up as a pupil "to learn the art profession and business of architect and the art of pattern designing".[60] In a letter to Haslam's father, William, at the end of his son's tenure, Voysey wrote that he could not "speak too highly of Robert's conscientiousness and diligence. And shall ever remember with gratitude his faithful service during the last three years. I hope that in the future, if I can be of any service to him, by counsel or otherwise, he will not hesitate to come to me".[61]

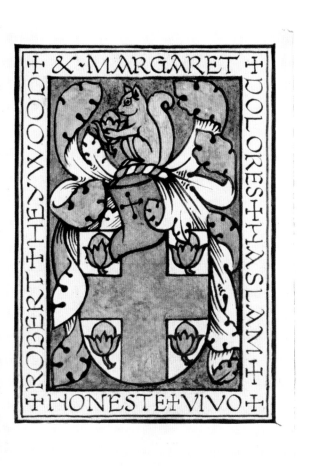

Figure 64
KATHLEEN MÜNTZER, after 1904
Print
13.3 x 8.3cm (5¼ x 3¼in.)

This is one of three bookplates drawn by Voysey that illustrates a ship and mountains, with the sun radiating behind them, in a bold, monochrome style. Voysey wrote that "this book plate was designed for a lady who was fond of reading, mountain scenery and travel, which latter the ship denotes. The forest in the middle distance and the wild beasts of the night, are meant to indicate the kind of literature most favoured by the owner. 'Sine libris tenebrae'. Without books (there is) darkness".[62] The design was published in Voysey's 1929 article "Modern Symbolism" in *The Builder*.

The lady in question was Kathleen Müntzer, who married George Frederick Müntzer in 1904. George (1877-?) worked as a building contractor in his family's firm, based in Farnborough, Kent. The Müntzers built houses for both Voysey and Edwin Lutyens, and Voysey formed a strong friendship with the family. In 1906 he designed Littleholme, in Guildford, Surrey, for the Müntzers. The house and its garden – published in Gertrude Jekyll's seminal 1912 book, *Gardens for Small Country Houses* – were conceived as one harmonious entity. George's younger brother, Thomas (1881-?), was Voysey's pupil beginning in 1899, and he went on to design an extension to Prior's Field School (see Figures 114-116), which had been converted from a house designed by Voysey in 1900.

Figure 65
PHILLIS REDFERN, n.d.
Print with added watercolour and metallic ink
10.5 x 7.1cm (4⅛ x 2¹³⁄₁₆in.)

Combining an armorial shield and the motif of a bird sitting in an olive tree, this bookplate design is one of only a few by Voysey that were produced in colour. The designer described the eagle among the olive branches as being "far seeing and peaceful".[63] The band of "Gothic clouds" along the bottom edge was one of Voysey's favourite themes, although he found that books on heraldry were "conspicuously silent" on the meaning of the symbols on the shield.[64]

This bookplate was designed for Phillis Redfern (1896-?), the second daughter of Harry Redfern (1861-1950), a fellow of the RIBA, the chief architect of the Central Control Board (later the State Management System), for which Voysey volunteered during World War I by designing posters (see Figures 130 and 131). In the 1930s Redfern was tasked with designing a series of "New Model Inns" – light, airy pubs that were easy to supervise, had comfortable surroundings and were made for food service and recreation – all in the Arts and Crafts style. Redfern was a great admirer of Voysey and he is listed in Voysey's address book, both at the Central Control Board's headquarters in Canada House, London, and at his home in East Acton.

Architects and Associates

PHILLIS·REDFERN

Figure 66
RUDOLF DIRCKS, 1920-30
Print
13.4 x 10.1cm (5⁵⁄₁₆ x 4in.)

Voysey wrote that "this book plate is supposed to represent the spirit of the librarian and author, the owner fulfilling both functions. The guardian angel holds in its hands the pen and inkhorn. And has chained to its neck a book and rises from the old familiar gothic symbol of a cloud. The cross and heart terminals of the bookmarks suggest faith and love respectively".[65] An alternative version of this design in the collection of the RIBA includes the motto "Ready to serve" on the pages of the book.

Rudolf Dircks was the librarian of the RIBA in the 1920s, as well as a writer on art and architecture. His publications included monographs on Lawrence Alma-Tadema, Auguste Rodin and Sir Christopher Wren. Voysey and Dircks knew each other through the events and activities organised for fellows of the RIBA. During the discussion that followed one lecture given by Dircks on the library and collections of the RIBA, Voysey commented that "libraries were to a large extent responsible for the badness of modern architecture … while we were hoarding other people's works we were neglecting our own modern conditions. The greatest architecture the world had ever seen had grown out of a complete understanding of the requirements and conditions which were purely local. It was Descartes who said that the more we were interested in and concerned with the past, the less we understood and appreciated the present".[66]

Architects and Associates

RUDOLF·DIRCKS

C·F·A·V·

Figure 67
WILLIAM AUMONIER, 1929
Print
15.6 x 7.6cm (6⅛ x 3in.)

Signed and dated 1929, this bookplate reflects Voysey's passion for the Gothic style, which he shared with its owner, William Aumonier (died 1913). The design was created "for one of Huguenot descent, hence the fleur-de-lis. The name Aumonier means almoner, hence the purse in the right hand. But as Ruskin said, the greatest of charity was the giving of praise, a laurel wreath is preferred. The canopy and Gothic cloud are allusions to the owner's craft as an ecclesiastical carver".[67]

By the time his career began to flourish in the mid-1890s, Voysey had established relationships with a number of small specialist manufacturers that made furniture, architectural metalwork and other decorative furnishings from his designs. Among these was the firm of William Aumonier, an architectural sculptor and brick- and wood-carver based in New Inn Yard, Tottenham Court Road, London. One of Aumonier's best-known commissions was the terracotta sculpture and ornament on the New Victoria Law Courts, Birmingham (1886). In 1891 Voysey was commissioned to make some alterations to the Aumonier family home, Russel House, in Hampstead.

Architects and Associates

WILLIAM: AUMONIER

C.F.A Voysey
1929

Artists and Musicians

Figure 68
FRANK SPENLOVE-SPENLOVE, 1915
Print
13.6 x 9.4cm (5⅜ x 3¹¹⁄₁₆in.)

Designed for Voysey's friend Frank Spenlove-Spenlove (1868-1933), a landscape and figure painter, this bookplate is an adaptation of the Spendlove family coat of arms, to which Voysey added a pistol and horn, along with the motto "Ready aye ready". Expenses related to the design of this bookplate were entered in Voysey's ledger of professional expenses on 4 March 1915. The shield and motto are repeated on the letterhead that Voysey designed for the painter's London home at 65 Eton Avenue N.W. (see Figure 69).

In 1896 Spenlove-Spenlove founded the Spenlove School of Modern Art, known as the Yellow Door School, in Beckenham, Kent. As he often did, Voysey composed a small poem about his friend, making reference to the school:

And as the peacock crew
Some stood before
the oriental vista of
a yellow door,
with blinds now compass-
-ionate they cried.
With water he came in,
With wind passed o'er[68]

Artists and Musicians

READY AYE READY

FRANK SPENLOVE-SPENLOVE

Figure 69
LETTERHEAD FOR 65 ETON AVENUE N.W., n.d.
Print
3.2 x 11.4cm (1¼ x 4½in.)

Figure 70
EMBOSSED LION RAMPANT, n.d.
Embossed
3.6 x 3.1cm (1⁷⁄₁₆ x 1¼in.)

In heraldry the lion rampant symbolises dauntless courage. This symbol appears in several of Voysey's bookplate, wallpaper and textile designs. He made many sketches and studies of lions rampant, some copied from books on heraldry that he purchased or studied from original coats of arms on bookplates in the collection of the British Museum.

65 ETON AVENUE N.W.

Figure 71
NELLIE AND ELSA OSBALDISTON, n.d.
Print
8.9 x 8.6cm (3½ x 3⅜in.)

Voysey designed this bookplate "for two professional musicians". It features "one harping angel with the lark surrounded by cloud".[69] Nellie and Elsa Osbaldiston are listed in Voysey's address book in Wilmslow, near Manchester. They are also recorded as having a music studio at Hill Top, Wilmslow. This was the area where Voysey's niece, Ella (see Figure 39), lived for a time and took music lessons; it is possible that the Osbaldistons may even have been her friends or tutors.

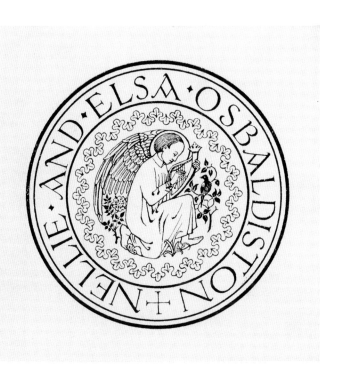

Figure 72
HAROLD SPEED, n.d.
Print
7.9 x 5.2cm (3⅛ x 2¹⁄₁₆in.)

The swift and the arrow flying over the sea create a direct representation of Harold Speed, for whom this simple but effective bookplate was designed. To Voysey, swallows represented faithfulness and constancy. Speed (1872-1957) was a landscape and portrait painter and an art writer. He initially studied architecture at the Royal College of Art but soon took up painting, and he continued his studies at the Royal Academy Schools between 1891 and 1896. He exhibited regularly and was a member of a number of clubs and societies, including the Art Workers Guild, of which he was Master in 1916. Speed produced two portraits of Voysey: the first, an 1896 chalk drawing, was acquired by Richard Walter Essex of Essex & Co. (see Figure 49); and the second, a 1905 oil painting, shows Voysey with his family's coat of arms in the background (see Figure 1). Voysey used the same coat of arms in his designs for bookplates for his son Charles Cowles-Voysey (see Figure 28).

Figure 73
HAROLD KNIGHT, 1930
Print
8.9 x 6.7cm (3½ x 2⅝in.)

Harold Knight (1874-1961), a painter specialising in portraits and interiors, first exhibited at the Royal Academy in 1896. He married the artist Laura Johnson, later Dame Laura Knight, in 1903. After their marriage the Knights lived at the artists' colony at Staithes in Yorkshire, moving in 1908 to Newlyn, Cornwall, where they stayed for ten years before settling in London. Knight is listed in Voysey's address book at his home in St. John's Wood, an area of London popular with artists, where Voysey also lived until he built The Orchard in 1899. Voysey described this as a bookplate for a "home builder (architect) and painter",[70] represented in the design by a pair of nesting birds, an architect's proportional compass and a painter's palette. It was designed in 1930 and expenses of one pound and one shilling related to the design were recorded in his ledger of professional expenses on 15 March of that year.

BY LOVE SERVE ONE ANOTHER

HAROLD ✝ KNIGHT

C.FAY.

Figure 74
ERNEST MOORE, n.d.
Print
12 x 6.8cm (4¾ x 2¹¹⁄₁₆in.)

This bookplate was designed for Ernest Moore (1865-1940), a portrait painter influenced by the French Realist tradition. Moore studied in London and Paris, where he also exhibited his work. His sitters included Members of Parliament and civic dignitaries. Moore and his wife are listed in Voysey's address book at residences in South Kensington and Battersea, London.

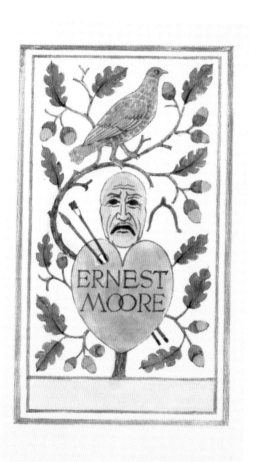

Figure 75
LOUIS GAUTIER EX LIBRIS, n.d.
Drawing in ink on linen
10.2 x 5.9cm (4 x 2⁵⁄₁₆in.)

Of this bookplate, Voysey wrote, "Louis Gautier, being president of the Magicians Club, bears their badge which is the pyramid and sphinx. His father was an architect who built bridges and ships and he is a descendant of the celebrated Gautier and a painter himself".[71] The bookplate design also incorporates the motto "Poeta nascitur non fit", meaning "The poet is born, not made".

Medical Professionals

Figure 76
THEO[PHILUS] BULKELEY HYSLOP, n.d.
Print
14.8 x 7.1cm (5¹³⁄₁₆ x 2¹³⁄₁₆in.)

Voysey's circle of friends at the Arts Club included several doctors. In this design, made for a psychiatric doctor with an active interest in the arts, he took the conventions of a traditional coat of arms and used more modern motifs to build a portrait of the owner. Voysey wrote, "From clouds two angels support the shield of a medical man who loved music, painting, games and joking".[72] The motto "Nil temere" means "Nothing rashly".

Theophilus Bulkeley Hyslop (1863-1933) was a senior physician at the Bethlehem Royal Hospital, London, a psychiatric hospital, as well as chairman of the Society for the Study of Addiction from 1910 to 1912. He was also an amateur artist and occasionally exhibited at the Royal Academy. In the outcry that followed the first Post-Impressionist exhibition at the Grafton Galleries in London in 1910, Hyslop was one of those who openly denounced the "degenerate" and "immoral" art. Organised by Roger Fry, the exhibition was the first time the British public had seen the work of Paul Cézanne, Paul Gauguin, Vincent van Gogh, Henri Matisse and other avant-garde painters from the Continent. In February 1911 Hyslop was asked by the artist George Clausen to lecture to the Art Workers Guild on the art of the mentally ill, a subject on which he was an expert and had published extensively. That same year, he also organised an exhibition of work by the mentally ill, in which he included a painting of his own.

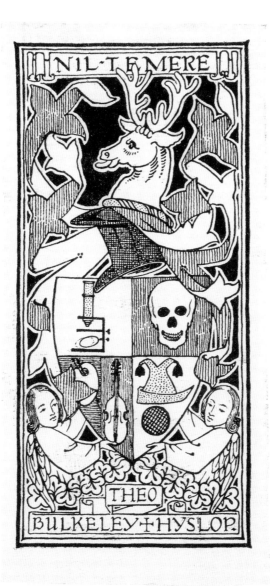

Figure 77
WILLIAM HUGH COWIE ROMANIS, n.d.
Drawing in ink and pencil
10.4 x 9.5cm (4⅛ x 3¾in.)

William Hugh Cowie Romanis was a surgeon who published many texts on the science and practice of surgery. His bookplate is "made up of traditional heraldry and leaving no room for other symbolism".[73] "Per incerta certus amor", meaning "Love certain through things uncertain", is the motto of the Romanis family. Because of the Scottish origins of the name, Voysey included thistles in the armorial design.

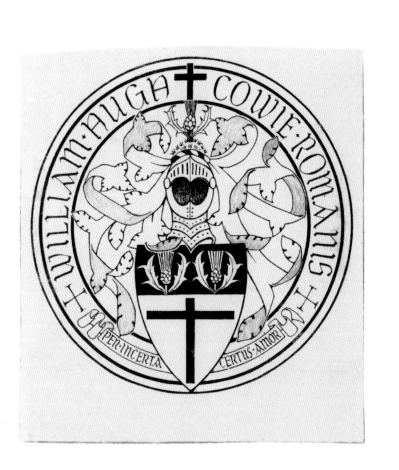

Figure 78
SANCT, n.d.
Print
10.2 x 5.2cm (4 x 2¹⁄₁₆in.)

Voysey designed this bookplate "for an Irish professional nurse and hence the cross which should be printed in red. The shillaleghs [*sic*] signify the ever-readiness for a row. The circle with its rays stands for the bright sunny glow … dominates the Red Cross Mission. And the crown which denotes self control, is made up of fleur-de-lis which stand for purity".[74]

A shillelagh is a wooden walking stick and club, typically made from a stout knotty stick with a large knob at the top, that is stereotypically associated with the Irish. The Latin word *sanct* at the top of the bookplate means "sacred or holy". There are two bookplates in the Crab Tree Farm album designed for Red Cross nurses; the other was made for Beryl Barendt, the daughter of Voysey's clients, Philip and Emma Barendt (see Figure 48).

Figure 79
MAURICE BERESFORD WRIGHT, n.d.
Drawing in ink on linen
15.6 x 15.2cm (6⅛ x 6in.)
(Illustration shown at 90% of actual size)

Maurice Beresford Wright was one of a number of Voysey's friends who were doctors and knew each other through their membership of the Arts Club. This bookplate combines lettering in the alphabet that Voysey designed with symbols taken from heraldry. The serpents entwined around a staff are the sign of Asclepius, the god of medicine, while the unicorn symbolises extreme courage. The motto "Ad rem" means "To the point in hand".

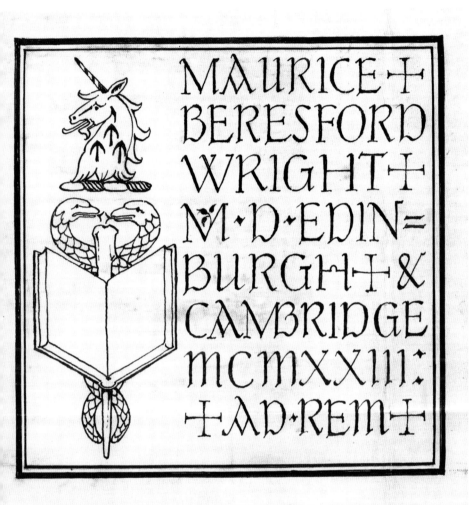

Figure 80
JAMES RISIEN RUSSELL, n.d.
Print
9.2 x 10.1cm (3⅝ x 4in.)

James Samuel Risien Russell was a professor of clinical medicine at the University College Hospital, London. He was a nerve specialist, as indicated by Voysey's design for an armorial-style bookplate that features "poppy heads and merry thoughts, [which] suggests the nervous treatment that soothes and makes merry".[75] Voysey and Russell knew each other from the Arts Club and the doctor is listed in Voysey's address book in Wimpole Street, London, along with a note about the names of his stepdaughters, Celia, Clement and Rosemary.

Medical Professionals

Others

Figure 81
DOROTHY ROSE, n.d.
Print
12.1 x 7.1cm (4¾ x 2¹³⁄₁₆in.)

From their beginnings in the fifteenth century, many bookplate designs have featured a play on the owner's name. Here Voysey used the rose as the background for the design, explaining that "Dorothy Rose's bookplate speaks for itself, though having little or nothing to say. A graceful and pretty growth associated with love, is the basic idea".[76]

Others

Figure 82
DOROTHY ROSE, n.d.
Print
12.1 x 7.1cm (4¾ x 2¹³⁄₁₆in.)

Others

DOROTHY. ROSE

Figure 83
MJB EAB, n.d.
Print
12.4 x 6.2cm (4⅞ x 2⁷⁄₁₆in.)

According to Voysey:

> This bookplate was designed to be the joint property of husband and wife, the initials of whom appear on the two shields. The crest and motto are the husband's traditional heraldic emblems. The family is interested in large fishing and transport trades. The two linked hearts suggest the affectionate union of husband and wife. Motto: Nunquam mutans = never changing.[77]

Several of the bookplate designs in the Crab Tree Farm album, such as this one, combine traditional armorials or heraldic emblems with Voysey's own symbolic language and pictorial arrangements. The same ship featured here, with a few additional details, is repeated in the bookplate for the actor Robert Donat (see Figure 40). Voysey made a particular study of heraldry and his portfolio of sketches and source material includes several studies of ships.

Others

Figure 84
VIOLET MACNAUGHTON, n.d.
Print
11.1 x 6.8cm (4⅜ x 2¹¹⁄₁₆in.)

Violet MacNaughton (1887-?) was the daughter of Norman MacNaughton, a specialist contractor who supplied stone for Dallas, the only house that Voysey designed and built in Ireland. Built in Malone Park, a private, leafy residential area of Belfast, Dallas was designed in 1911 for Robert Hetherington, a linen manufacturer, and was the last Voysey house to be built. The MacNaughtons lived just a few streets away from Dallas, as did Voysey's brother Ellison. In "Symbolism in Design" Voysey wrote:

> This book plate was made for a young Irish lady. Cupid with arrow ready to fly, in constant attendance. Figure suggesting reading and music on either side. Two hearts she hath, emblazoned with violets, one for private and one for public use. The shamrock tree, the emblem of Ireland, grows out of a violet bank and supports in its boughs the bird in its most typifying maternity. Above are two cooing turtle doves, the sign of love-makers, and below is the sagacious raven contemplating the book worm drawn in his book. The cap and bells denote the merry wit of the owner: and lastly, the swift, which more than all is the dominating characteristic of the lady.[78]

His description captured Violet MacNaughton's character and interests, suggesting his friendship with her and her family.

Others

Figure 85
C.A. ECCLES WILLIAMS, n.d.
Print
10.5 x 6.4cm (4⅛ x 2½in.)

Voysey designed a number of bookplates in the armorial style, which was one of the most traditional forms for a bookplate and particularly popular in the nineteenth century. He made a habit of studying coats of arms and their symbolic content, then adapting traditional designs and incorporating new details that reflected the interests of the bookplate's intended owner.

In this design, Voysey modified the coat of arms of the Williams family to create a bookplate that "is mainly composed of the traditional heraldic insignia of the family, and in addition, some tastes of the owner being painting and theatricals, will account for the mask and palette".[79] Voysey invented the motto, "Fidus in fidem"; it translates as "Faithful in faith".

Others

FIDUS · IN · FIDEM

C·A·ECCLES·WILLIAMS

Figure 86
CYNTHIA MARY WILM. CHAS. BARTON, n.d.
Print
12.1 x 6cm (4¾ x 2⅜in.)

In Voysey's designs, each motif and symbol represent a very specific meaning. He described this bookplate:

> [It] is the joint property of husband and wife. The lily signifies purity, the heart love and sympathy, the sturdy oak grows out of love and affords shelter for music, literature, architecture, sculpture, painting and love-making, which are the interests of the owners. Painting it will be noticed is the colouring of sculpture: or a carved object or something in the round which may be said to be the first expression of the painter's art, and a nobler form of art than picture painting, because wedded to structural function. And it must follow that if you first make all the necessities of life beautiful, we shall then be better able to appreciate picture painting.[80]

This symbolism encapsulates Voysey's views on the importance of the decorative arts over painting and the Arts and Crafts mandate that even objects of everyday use should be beautifully designed and made.

Others

I · BIDE MY TIME

Figure 87
FANNY CROMPTON, n.d.
Halftone
7.8 x 5.4cm (3¹⁄₁₆ x 2⅛in.)

This bookplate features a lark and cornflowers, along with a quotation from a song in Shakespeare's *Henry VIII* (Act III, Scene 1) written around the edges. In this scene Katharine of Aragon, anxiously awaiting news of Henry's attempt to divorce her, listens to songs about the soothing power of music. A woman sings for her:

> Orpheus with his lute made trees
> And the mountain-tops that freeze
> Bow themselves, when he did sing.
>
> To his music, plants and flowers
> Ever sprang; as sun and showers
> There had made a lasting spring.
>
> Everything that heard him play
> Even the billows of the sea
> Hung their heads, and then lay by.
>
> In sweet music is such art
> Killing care and grief of heart
> Fall asleep, or, hearing, die.

Voysey's preliminary sketch for this bookplate is in the drawings collection of the RIBA (see Figure 22). It was made with pencil on a piece of headed paper from the Design Club (see Figure 119). Voysey's notes include the reference to *Henry VIII* and a passage from *Romeo and Juliet* (Act III, Scene 5): "It was the lark, the herald of the morn". A further note reads, "The Lark Alauda Arvensis. Famous for its affections and gladsome and heart lifting notes". Voysey often made studies from nature and drew many species of birds, which he then used in designs such as this. On the finished drawing for this bookplate, a note to the printer reads, "Submit proofs before printing".[81]

Others

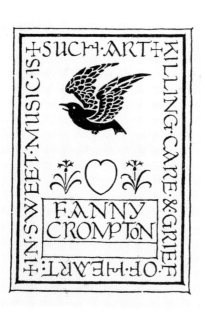

✠ SUCH·ART ✠ KILLING·CARE·&·GRIEF·OF·HEART ✠ IN·SWEET·MUSIC·IS

FANNY
CROMPTON

Figure 88
FREDERICK WILLIAM BROWN, n.d.
Print
10.6 x 7.6cm (4³⁄₁₆ x 3in.)

On the back of the original sketch for this bookplate, now in the drawings collection at the RIBA, Voysey noted: "The Guardian Angel records the qualities aspired to. The heron symbol of solitude, self reliant and self sufficient. The spirit that shrinks from lime light. The most individualistic of birds. The family tree on the banks of the river of life. 'Deeds not words'. May be taken in two ways. As a playful allusion to the lawyer owner, or as a veritable truth, of the desire to act secretly, doing good service by actions".[82]

Others

Figure 89

FREDERICK R.E. AND ISABEL EMERSON, n.d.

Drawing in ink on linen

11.1 x 10.5cm (4⅜ x 4⅛in.)

For this bookplate, in the armorial style, Voysey interpreted what he described as the "authentic heraldry" of the Emerson family, placing the symbols into a standard format that he adapted for several of the bookplate designs in the Crab Tree Farm album.[83] At the centre is a shield with three lions (which are found on the Emerson coat of arms), as well as a ship and the mottos "Sine metu" (Without fear) and "Deus protector noster" (God is our protector).

Others

FREDERICK ✝ R ✝ E ✝ AND ✝ ISABEL ✝ EMERSON ✝

SINE
METU

DEUS PROTECTOR
NOSTER

Figure 90
FLORENCE COLLINS, n.d.
Print
10.8 x 6.5cm (4¼ x 2⁹⁄₁₆in.)

This bookplate is characteristically simple and graphic. It is reminiscent of Voysey's later textile designs for nurseries, such as "The House That Jack Built" (1929). In "Symbolism in Design" he noted that this was a "bookplate for [a] lover of natural history" and that he had left "space for recording [the] date when the book was obtained".[84]

Others

Figure 91
CORNELIA CRACKNELL, n.d.
Drawing in ink
8.6 x 7.6cm (3⅜ x 3in.)

This round bookplate represents a variation on the theme of an olive tree with birds. In "Symbolism in Design" Voysey wrote that the olives and doves both symbolise peace.[85]

Others

Figure 92
PHYLLIS REYNOLDS, n.d.
Print
10.2 x 6.7cm (4 x 2⅝in.)

This bookplate, made for Phyllis Reynolds, has a "wild deer bounding over a flowery glen by the side of a forest: showing fondness for wild nature".[86] Animals and nature were common themes for Voysey and several of his wallpaper and textile designs feature leaping deer very similar in style to the one in this bookplate. Voysey often made trips to London Zoo to draw animals and birds and he also made studies from

Others

Figure 93
PHYLLIS REYNOLDS, n.d.
Print
10.2 x 6.5cm (4 x 2%₆in.)

reference books. Deer would occasionally have appeared in the garden of his home, The Orchard, which overlooked a valley populated by many birds and wildlife. This bookplate was printed in two alternative colours, blue and green. It was published in *The Builder* to illustrate Voysey's 1918 lecture "Modern Symbolism", given at Carpenters' Hall, London.

Others

Figure 94
PHYLLIS REYNOLDS, n.d.
Print
15.2 x 10.9cm (6 x 4¼in.)

Others

PHYLIS·REYNOLDS·

Figure 95
BEDGEBURY PARK, GOUDHURST, KENT, n.d.
Drawing in ink
14 x 11cm (5½ x 4%₆in.)

Bedgebury Park, an imposing house in Goudhurst, Kent, was the home of the Beresford family from 1836 to 1900. In 1854 it was inherited by A.J. Beresford-Hope, president of the Ecclesiological Society and a patron of Gothic Revival architecture. Between the 1860s and 1880s, the estate housed a skilled workshop with craftsmen specialising in marquetry. They produced a series of marquetry panels with depictions of characters from the Old and New Testaments, as well as flowers, fruit and birds. One panel includes a grapevine, an image that is repeated in this bookplate by Voysey. The design also incorporates a fleur-de-lis, representing purity, and the motto "Semper fidelis", which means "Always faithful".

Others

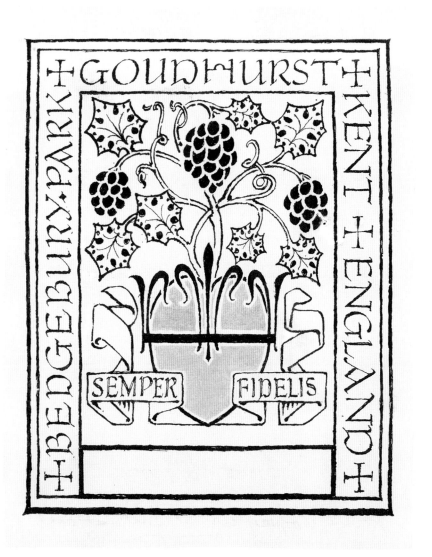

✠ GOUDHURST ✠ KENT ✠ ENGLAND ✠ BEDGEBURY·PARK ✠

SEMPER FIDELIS

Figure 96
INDA HENDERSON, 1923
Print
9.4 x 8.4cm (3¹¹⁄₁₆ x 3⁵⁄₁₆in.)

Voysey designed this bookplate in 1923 and costs related to the design are recorded in his ledger of professional expenses for 8 June of that year. In "Symbolism in Design", he described "the rose, shamrock and thistle beneath the English oak where sits the wise owl" and "the heart denoting human affection".[87]

Others

Figure 97
STANLEY AUSTIN, n.d.
Print
9.2 x 5.5cm (3⅝ x 2³⁄₁₆in.)

Stanley Austin's bookplate draws on Voysey's knowledge of armorial-style bookplates and heraldry. The Paschal Lamb is a Christian symbol, also seen on the badge that Voysey designed for the Archdeacon of Rochester (see Figure 41). The ecclesiastical figure in the centre is Saint Peter, who is shown holding the keys to the kingdom of heaven.

Others

STANLEY·AUSTIN

Figure 98
MARGARET HUMPHREY WILLIAMS, n.d.
Print
7.9 x 4.8cm (3⅛ x 1⅞in.)

This design, made for Margaret Humphrey Williams, is one of five bookplates of this shape, called a *vesica*, by Voysey. It combines elements of heraldry, which he studied as a hobby. In a coat of arms, a stag usually represents peace and harmony.

Others

Figure 99
WILLIAM INGLIS, JUNR., n.d.
Print
10.3 x 8cm (4¼₆ x 3⅛in.)

This bookplate is very similar in format and style to the one designed for Kathleen Müntzer (see Figure 64) with a ship in the foreground and the radiating sun behind a mountain. Sailing ships, or galleons, were often used as motifs in Arts and Crafts designs and Voysey employed them in several of his designs for bookplates, textiles and wallpaper. This bookplate may have been commissioned or created in consultation with the owner; Voysey wrote that "with words chosen by the American owner no further explanation is needed".[88] This design was published in his 1929 article "Modern Symbolism" in *The Builder*.

Others

WILLIAM·INGLIS·JUNR·
THIS·MY·HEAVEN·OF·BEAUTY ✝
THIS·MY·MOUNTAIN·OF·MAJESTY
THIS·MY·SEA·OF·EXULTATION ✝
THIS·MY·BOAT·FOR·A·LONG·JOURNEY
THIS·IS·MY·LEARNING·THIS·IS·MY·BOOK

Figure 100
WALTER ALBERT NEVILL MACGEOUGH BOND, 1929
Print
10.2 x 9.2cm (4 x 3⅝in.)

This bookplate uses the same design as the bookplate created for Nellie and Elsa Osbaldiston (see Figure 71). It was made for Walter Albert Nevill MacGeough Bond (1908-1986), an Irish landowner who held the offices of High Sheriff (1953) and Deputy Lieutenant (1960-61) of County Armagh, as well as serving as an active patron of the arts. He had a large personal collection of paintings and sculptures at his home, The Argory, and was also an accomplished pianist and organist. This interest is reflected in his bookplate, which depicts an angel playing a lute.[89]

Others

Figure 101
WILHELMINA HELENA VAN O BRUYN, n.d.
Drawing in ink on linen
15.6 x 10cm (6⅛ x 3¹⁵⁄₁₆in.)

This charming design for a bookplate features an ark with a dove and olive branch, a seahorse, a Lars Gibbon, a bear, a fleur-de-lis and the Greek letters alpha and omega. Voysey made many studies and line drawings of animals and he visited London Zoo to draw the animals there. Pared down to simple but expressive lines, the animal motifs he drew were often reused in different contexts and designs. This bear, for example, was one of the animals featured in a series of animal badges designed by Voysey in 1927. An alternative design for a bookplate for Wilhelmina Helena Van O Bruyn is in the drawings collection at the RIBA. It features a black cross on a gold ground.[90]

Others

Figure 102
MARGARET BARLOW, n.d.
Print
10.8 x 9.5cm (4¼ x 3¾in.)

This round design features an owl, rabbit, squirrel and dove sitting in an
olive tree, with meadow flowers including bluebells and dandelions
surrounding them. Voysey often reused his designs for different purposes
and this bookplate is the same as the one made for Phyllis Elizabeth and
Annesley, Voysey's youngest son and his wife (see Figure 33).

Others

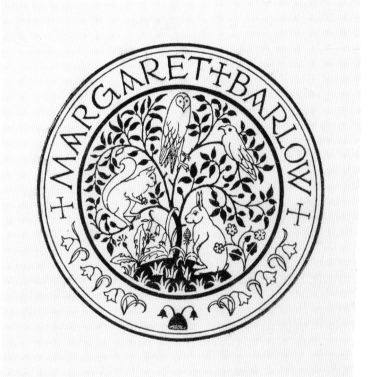

Figure 103
DORA AND ISABEL WILLIAMSON, n.d.
Drawing in ink
8.9 x 8.6cm (3½ x 3⅜in.)

Voysey often described the eagle as the "highest flier and furthest seer".[91] Here an eagle is perched on a heart, against a backdrop of mountains and a Gothic cloud. The device is reminiscent of the letterhead designed for Mabel Ritchie (see Figures 104-107).

Others

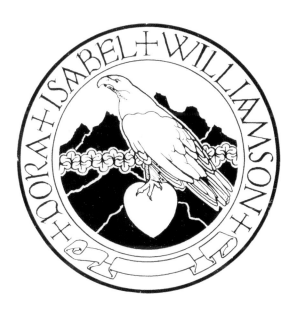

Figure 104
MABEL RITCHIE LETTERHEAD, c.1936
Print
4.2 x 11.2cm (1¹¹⁄₁₆ x 4⁷⁄₁₆in.)

Voysey often designed letterhead for friends and clients. This example is dated 1936.

54·BASSETT·ROAD
LONDON·┼·W·10
TELE┼PARK·5953

Figure 105
MABEL RITCHIE LETTERHEAD, n.d.
Print
3.8 x 4.5cm (1½ x 1¾in.)

Others

208

Figure 106
MABEL RITCHIE LETTERHEAD, n.d.
Print with added gold
3.8 x 3.8cm (1½ x 1½in.)

Figure 107
MABEL RITCHIE LETTERHEAD, n.d.
Drawing in ink
2 x 3.8cm (¾ x 1½in.)

54 BASSETT·ROAD
LONDON·I·W·IO
TELE·+·PARK·5953

Others

Schools

Figure 108
EX CORDE VITA, 1910
Drawing in ink
5.9 x 4.9cm (2⁵⁄₁₆ x 1¹⁵⁄₁₆in.)

There are seven designs for school badges and bookplates in the Crab Tree Farm album. This one was produced in 1910 as an alternative to Voysey's original 1898 design for King Alfred's School, London (see Figure 109). The design was conceived as "the heart [which] nourishes the tree of knowledge, [with] self-control being indicated by the crown around the heart. [The motto] 'Ex corde vita' means Reality is from the heart".[92] A sample of this school badge, produced in woven yellow and blue silk, but without the motto, is in the collection of the RIBA.

Schools

EX·CORDE·VITA

Figure 109
THE KING ALFRED SCHOOL SOCIETY, 1898
Print
9.2 x 7cm (3⅝ x 2¾in.)

The King Alfred School Society was founded in 1897 as a charitable organisation aimed at promoting rational and progressive education. In 1898 the society founded King Alfred's School in Hampstead, which still thrives today, though it now uses a modernised version of the badge designed by Voysey. The founding committee of the school included Hamo Thornycroft, a sculptor and founding member of the Art Workers Guild, of which Voysey was also a member. Voysey designed this badge in 1898 and another simpler version in 1910 (see Figure 108). In "Symbolism in Design" he wrote:

> The badge of the King Alfred School suggests that out of the heart springs the fruitful tree of knowledge, and upon the heart is engraved the image of the Good King Alfred with the initials he used on the gold coins of his day. The heart is surely the fruitifying medium of the mind, converting knowledge into Wisdom. In the book we find Proverbs II. 6: "For the Lord giveth wisdom. Out of His mouth cometh knowledge and understanding". Which must mean, that through the heart of man He sendeth knowledge and understanding.[93]

Voysey and his wife, Mary Maria (see Figure 26), were actively involved in the early development of the school, attending the annual general meetings until 1917. All three of their children were educated there: Charles from September 1898 to July 1905, Annesley from January 1907 to July 1912 and Priscilla from September 1911 to July 1914. In 1920 the school moved from Ellerdale Road, Hampstead, to Manor Wood, Golders Green. Charles Cowles-Voysey was involved with plans to develop the new site, but these were never realised due to insufficient funds.[94]

Schools

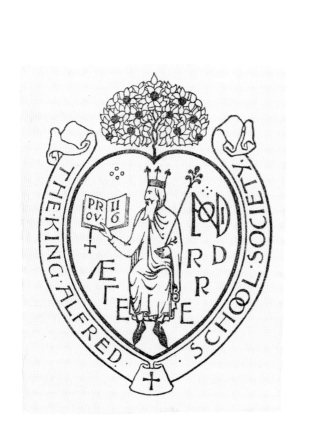

Figure 110
THE KING ALFRED SCHOOL SOCIETY, 1898
Print with added colour
9.2 x 6.8cm (3⅝ x 2¹¹⁄₁₆in.)

Schools

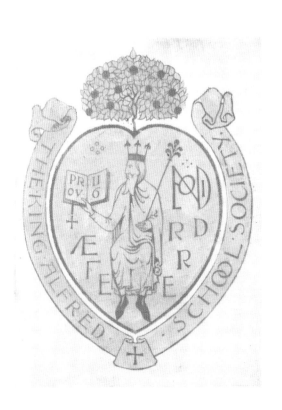

Figure 111
SCHOOL BADGE, n.d.
Drawing in ink on linen with watercolour wash
10.8 x 8.9cm (4¼ x 3½in.)

One of seven school badges in the Crab Tree Farm album, this design employs simple, clear symbols. The book denotes knowledge, while the bookmarkers that hang from it symbolise faith and love. The sword shows readiness for conflict and the crown is representative of control. The vesica shape was used by Voysey for five other bookplate designs in the album.

Figure 112
SCHOOL GRAMMAT LINCOLNIENS
[Lincoln Grammar School], c.1901
Print
15.2 x 12.5cm (6 x 4¹⁵⁄₁₆in.)

This badge is based on the traditional coat of arms of Lincoln Grammar School. It was probably made around 1901, when Voysey was invited to enter a competition to design a new grammar school for Lincoln. A previous client, F.H. Chambers, had been appointed as the new headmaster of the school and had recommended Voysey for the job. His competition entry was unsuccessful, but his drawings were published in *Building News* and exhibited at the Royal Academy Summer Exhibition in 1905.

The badge, in the form of a buckle, incorporates the little-used flag of Lincolnshire, which itself includes the Saint George's Cross and a central fleur-de-lis, usually yellow or gold in colour. The use of the lily hearkens back to a pre-Reformation time, when Lincoln Cathedral was Catholic (it is now part of the Church of England). The lily symbolises purity and the Virgin Mary, who is represented in Gothic style.

Schools

Figure 113
VIRGIN AND CHILD WITH MOTTO
(Hillside Convent College), 1925
Print
9.2 x 5.7cm (3⅝ x 2¼in.)

This bookplate was designed for Hillside Convent College, Farnborough, Hampshire. In his description in "Symbolism in Design" Voysey explained: "The hill on which the convent stood was known as Sycamore Hill, the Virgin and Child are strictly traditional".[95] The school was founded by the nuns of the Congregation of Christian Education in 1889. The school motto, which is incorporated into this plate, was "In domino labor vester non est inanis", meaning "Your labour in the Lord is not in vain".

According to Voysey's "Black Book", the bookplate was commissioned, along with a "circular heading", by the Reverend Mother of Hillside Convent College in 1925. In a letter to Voysey, which accompanied a cheque for the designs, one of the nuns at the convent wrote: "We feel very much in your debt over this matter, and like your design more, every time we see it! We hope that the closing of this transaction will not be also the closing of our acquaintance, and Reverend Mother wishes me to tell you again how pleased we should be to see you at Hillside, if ever you chance to be near us!"[96]

Figure 114
PRIOR'S FIELD GODALMING, 1925
Print
5.1 x 4.5cm (2 x 1¾in.)

In 1925 Voysey was asked to design both the school badge and a bookplate for Prior's Field, a progressive school in Godalming, Surrey. His resulting design represents "the olive tree of peace, in which sits the bird of wisdom, springing from the heart which is love, crowned by the restraining diadem of self control"[97]. It is still in use today by the school.

The school building itself was originally designed by Voysey as a house for F.H. Chambers in 1900. Chambers never moved into the house (instead, he relocated to become headmaster at Lincoln Grammar School – see Figure 112) and in 1901 the building was purchased by Julia Huxley, niece of the poet Matthew Arnold, so that she could fulfil her dream of opening a school for the advancement of girls in education and science. Thomas Müntzer, Voysey's pupil and the son of his regular contractor (see Figure 64), designed additions to the school in 1904.

Schools

Figure 115
PRIOR'S FIELD GODALMING, n.d.
Print
8.4 x 7.3cm (3⁵⁄₁₆ x 2⅞in.)

Schools

Figure 116
PRIOR'S FIELD GODALMING, n.d.
Print
9.5 x 7.9cm (3¾ x 3⅛in.)

Schools

Figure 117
TRINITY COLLEGE OF MUSIC, n.d.
Drawing in ink on linen
20 x 12.5cm (7⅞ x 4¹⁵⁄₁₆in.)
(Illustration shown at 95% of actual size)

Saint Cecilia is the patron saint of music, thus it is appropriate that Voysey chose to depict her in this bookplate for Trinity College of Music, London, founded in 1872 by the Reverend Henry George Bonavia Hunt to improve the teaching of church music. Initially only male students could attend and they had to be members of the Church of England. In 1881 the college moved to Mandeville Place, off Wigmore Street, in central London, which remained its home until its relocation to the old Royal Naval College building in Greenwich in 2001. Today it is an internationally renowned centre for the study of music.

Voysey also drew an alternative version of this design in colour, which he inscribed on the back with a poem:

> Listen to the music of my heart
> Which birds do bring upon the wing
> All I would sing
> If only I with subtle art
> Could reach your heart.

Schools

St. C

GLORIA·IN·EXCELSIS

TRINITY·COLLEGE·OF·MUSIC

Figure 118
St C [Saint Cecilia], n.d.
Drawing in ink and watercolour
17 x 11.4cm (6¹¹⁄₁₆ x 4½in.)

Schools

S^t.

C

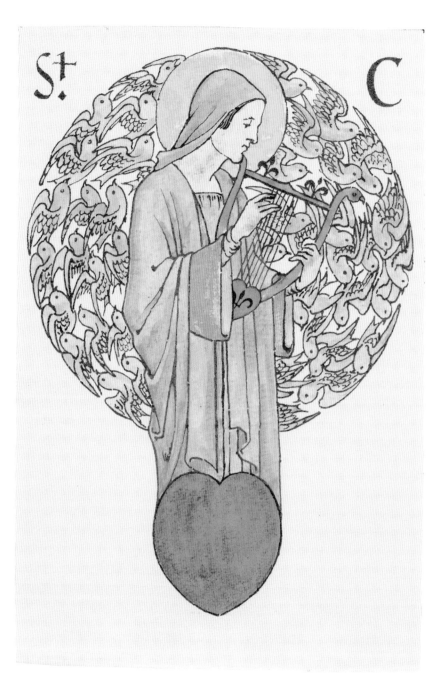

Clubs

Figure 119
THE DESIGN CLUB, 1909
Drawing in ink
Diameter 6cm (2⅜in.)

The Design Club was founded in 1909; Voysey, Lewis F. Day, Lindsay P. Butterfield and Arthur Lasenby Liberty were on the founding committee. The club was "specially intended for those architects who take pleasure in designing their own interior furniture and decorations".[98] Voysey designed this badge for the club, along with an invitation to the opening of its premises at 22 Newman Street. In the announcement of the opening of the club in 1909 it was noted that "the mystical symbol at the top is intended to express the essentials of design – Head, Heart and Hand, 'the head crowned with the band of restraint'. The meaning of the symbol is better than its decorative effect, which is not very attractive; but the writing … is a fine example of script".[99] This design was also published in *The Builder* to illustrate Voysey's 1918 lecture "Modern Symbolism".

Clubs

Figure 120
ARTS CLUB SYMPATHY CARD, n.d.
Print
13.3 x 7.9cm (5¼ x 3⅛in.)

Voysey often designed cards, invitations, letterheads and pamphlets for his friends and the organisations with which he was affiliated. He was a longtime member of the Arts Club, which was almost his second home in later life, and there he would have come across members from all of the professions indicated in this card. These he described as being represented by "the globe beneath the clouds, angels above supporting sympathy and love from which all arts evolve. Proportional compasses, denote Architecture; the lyre, music; the book, literature and science; chisel and mallet, sculpture; palette and brushes, painting; With the grape growing out of the heart there cometh much fruit".[100] The design was published in Voysey's 1929 article "Modern Symbolism" in *The Builder*.

Clubs

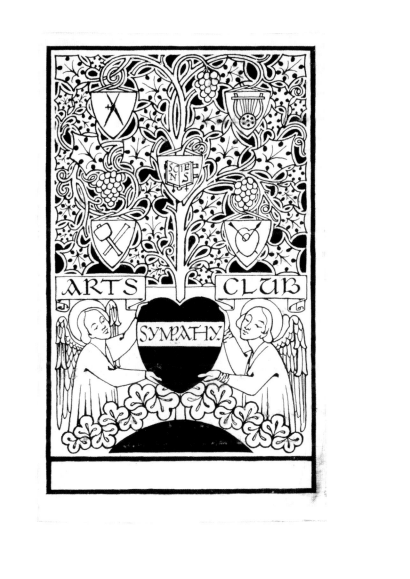

Figure 121
AC (MONOGRAM OF THE ARTS CLUB), 1920
Print
2.9 x 2.9cm (1⅛ x 1⅛in.)

In "Symbolism in Design" Voysey recorded this design as the "monogram of [the] Arts Club with the border [representing the] members laced hearts".[101] Voysey spent much of his spare time at the Arts Club in Dover Street, London, especially after 1917, when he returned to live on his own in central London and rented a small flat on St. James's Street. He was a popular and active member of the club and he made many friends there, for some of whom he designed bookplates. He also designed a bookplate (see Figure 122) and sympathy card (see Figure 120) for the Arts Club.

Clubs

Figure 122
THE ARTS CLUB, 1920
Print
6.8 x 5.6cm (2¹¹/₁₆ x 2³/₁₆in.)

The Arts Club was founded in 1863 by Lord Leighton and Charles Dickens. Since its founding, its membership has included many eminent artists and authors, "home to the Muse and the Amuse". A similar design is still in use by the club today, although this version, "representing Leonardo da Vinci", includes a different portrait head from the one in the Crab Tree Farm album.[102] Voysey copied portrait heads like the one seen here from a

Figure 123
THE ARTS CLUB, 1920
Embossed
4.3 x 4cm (1$^{11}\!/_{16}$ x 1$^{9}\!/_{16}$in.)

book on Leonardo da Vinci in the British Museum library. His ledger of professional expenses records costs related to the design and production of this bookplate on 6 November 1918 and again on 26 January 1920, when he paid ten shillings for the "description of Arts Club bookplate & 50 prints & block". Later, in January 1926, he also made a preliminary drawing for a bookplate for the Arts Club that was "not carried out".[103]

Clubs

Institutions

Figure 124
CHAMBER OF COMMERCE, DEPTFORD, n.d.
Print
Diameter 7.6cm (3in.)

Here Voysey took a traditional design and applied his own approach, making it "as simple and clear as . . . [he] was able to make it, in order that it could be used in varying sizes, and seen at varying distances".[104]

The Chambers of Commerce is a network for local business communities that provides representation, services, information and guidance to its members. The riverside borough of Deptford, in south-east London, is represented symbolically in this design by its historic naval associations. Between the sixteenth and eighteenth centuries, the Royal naval dockyard, originally founded by Henry VIII, was located in Deptford.

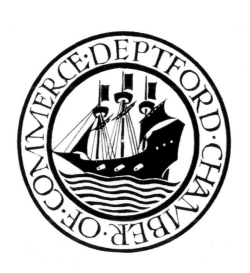

Figure 125
IAL [The Imperial Arts League], c.1909
Print
8 x 7.3cm (3⅛ x 2⅞in.)

Institutions

Figure 126
IAL [The Imperial Arts League], 1911
Embossed
Diameter 7.6cm (3in.)

According to Voysey, this is a "seal suggested for the Imperial Arts League".[105] An alternative design for the IAL is also included in the Crab Tree Farm album (see Figure 125). The Imperial Arts League was founded in 1909 as a kind of trade union intended to provide legal advice and guidance and to protect and promote the interests of artists and craftsmen on matters such as copyright. The league was directed by a council of experienced artists, who represented different societies and fields of activity and volunteered their services. Membership was by subscription and Voysey was one of the first to sign up. He also served on the council alongside George Frampton, Walter Crane, Selwyn Image, E.J. Horniman and Andrew Noble Prentice (see Figure 58). In 1971 the Imperial Arts League changed its name to The Artists League of Great Britain.

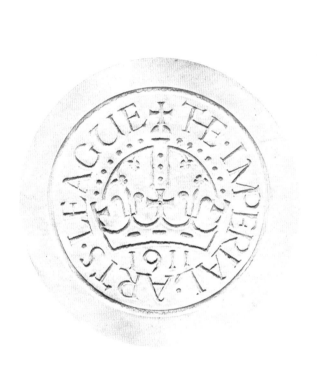

Figure 127
THE ESSEX AND SUFFOLK EQUITABLE INSURANCE
SOCIETY LIMITED, 1906-10
Photostat of design in unknown medium
9.8 x 8.7cm (3⅞ x 3⁷⁄₁₆in.)

Voysey was a friend of Sydney Claridge Turner, the secretary and general manager of the Essex and Suffolk Equitable Insurance Company, designing a home for him in 1905. The Homestead, on the coast at Frinton-on-Sea, was intended to be a place where Turner could indulge in his favourite pastime of playing golf and entertain guests for the weekend. This commission gave Voysey the rare opportunity to design not just a house, but also all of its furnishings and fittings.

Voysey's friendship with Turner later led to his commission for the remodelling of the Essex and Suffolk offices. Turner had lobbied Parliament to change a law that restricted the areas in which insurance companies could trade. At the successful overturning of that rule in 1906, his company began to expand, requiring new offices. Voysey was invited to decorate and furnish these offices over a number of years.[106] Throughout the decorative schemes he was able to indulge his interest in designing armorials and badges with a range of armorial stained-glass windows, badges and monograms that appeared on fireplaces and furniture in the office and the general manager's rooms.

Figure 128
CIVIC SURVEY OF GREATER LONDON, 1915
Drawing in ink and watercolour
Diameter 11.1cm (4⅜in.)

This badge was designed for use in various contexts, in black, white or full colour. As Voysey explained:

> The Civic Survey of Greater London for its badge has two good spirits, one casting light while the other is recording. That is to say, the collecting of facts and the making of diagrammatic records of the same. The ribbon being left for the insertion of the date when the diagram is made, to which the badge is attached. The work of the Civic survey of Greater London was the collecting of all facts concerning the Civic life of the people and recording in diagrammatic form those facts when collected and classified. These documents are now in the possession and keeping of the London County Council. They refer to Greater London only.[107]

This badge was used in a variety of ways, including on a map of London designed by Voysey in 1916 for use by soldiers and sailors; the map identified the locations of YMCAs, baths and swimming facilities, accommodation, food and recreation. The badge was also used on the cover of a visitors' book for the Civic Survey. The design was published in Voysey's 1929 article "Modern Symbolism" in *The Builder*.

Figure 129
CIVIC SURVEY OF GREATER LONDON, 1915
Print
Diameter 11.4cm (4½in.)

Institutions

Figure 130
CENTRAL CONTROL BOARD (LIQUOR TRAFFIC), 1915-18
Print
4.6 x 4.6cm (1¹³⁄₁₆ x 1¹³⁄₁₆in.)

During World War I Voysey volunteered for the Central Control Board (Liquor Traffic), designing posters and badges for use as part of its promotional efforts. As he noted:

> This is the badge used on the diagrams and documents made for the Central Control Board (Liquor traffic) and for the decoration of the wall in the "Greyhound" Inn at Enfield. "Se coercere" = Control Thyself! The crown stands for self-control: the heart symbolises the affections and emotions. The fleur-de-lis denotes purity: the vine, as a background to these qualities, may prove both useful and beautiful. So it is obvious that the Board is not a rabid teetotal Institution.[108]

The Central Control Board (Liquor Traffic) was set up by the British government in 1915 to control the nation's drinking habits during the war. One of the measures introduced was limiting the opening hours of pubs, a restriction that remained in force until "all-day" opening was reintroduced in 1988 (except on Sundays, which were not included until the late 1990s).

CENTRAL + CONTROL + BOARD
LIQUOR TRAFFIC

SE COERCERE

Figure 131
CENTRAL CONTROL BOARD (LIQUOR TRAFFIC), 1915-18
Drawing in ink and watercolour
10.2 x 9.4cm (4 x 3$^{11}/_{16}$in.)

Institutions

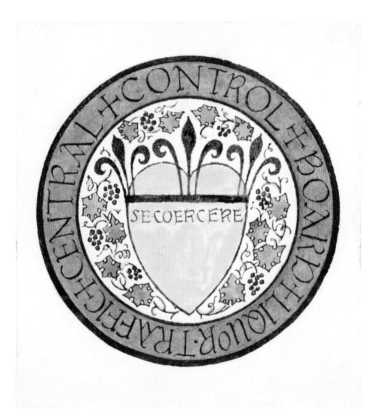

Figure 132
THE BROCKLEY PERMANENT BUILDING SOCIETY, 1922
Print
Diameter 5.1cm (2in.)

The commission for this badge is noted in Voysey's "Black Book" and dated 1922. The design is a roundel containing two birds building a nest. In "Symbolism in Design" the designer wrote that "birds being the first builders. The Brockley Building Society happily emulates them".[109]

Institutions

Figure 133
THE BROCKLEY PERMANENT BUILDING SOCIETY, 1922
Print
3.8 x 3.7cm (1½ x 1⁷⁄₁₆in.)

Institutions

Figure 134
THE ARMS OF THE BOROUGH OF WIMBLEDON, 1923-27
Print with added colour
12.9 x 9.2cm (5¾₆ x 3⅝in.)

This drawing reproduces the coat of arms of the Borough of
Wimbledon, in south-west London. The arms were granted in 1906 and
the accompanying motto, "Sine labe decus", means "Honour without
stain". Voysey undertook one project in Wimbledon: a house and stables
designed in 1899 for Cecil Fitch (now demolished). In 1927 he also
entered a competition to design Wimbledon Town Hall. On 14 June
1923 he paid five shillings for a book on the arms of London districts,
from which he may have copied this coat of arms. The design was
included as part of his competition entry, which was unsuccessful.

SINE · LABE · DECUS

The Arms of the borough of Wimbledon

Figure 135
THE ROYAL INSTITUTE OF BRITISH ARCHITECTS [RIBA],
1932
Print
19.7 x 14.9cm (7¾ x 5⅞in.)

This is a copy of the coat of arms of the RIBA, the British body for
architecture and the architectural profession. Voysey was an RIBA
fellow and he formed many of his professional contacts and personal
friendships through the organisation, which awarded him a Gold Medal
in 1940. He considered this to be "the highest award British
Architecture can give" and the professional recognition made him very
proud.[110] This version of the RIBA coat of arms was first designed by
J.H. Metcalfe in 1891 and it remained in use until 1931.[111] Voysey's
ledger of professional expenses records the sum of two shillings and
eight pence paid for "prints of RIBA bookplate" on 2 May 1932.

Institutions

THE ROYAL INSTITUTE OF BRITISH ARCHITECTS · 1834 ·

INCORP
1837
1887

VSVI · CIVIVM · ĐECORI · VRBIVM

Figure 136
ROSERING LIMITED, 1928
Print
2.9 x 15.7cm (1⅛ x 6³⁄₁₆in.)
(Illustration shown at 85% of actual size)

A 1928 entry in Voysey's "Black Book" records his commission by Maurice E. Webb to design this "Badge and Heading for Rose and Ring". The resulting designs are not particularly original, adapting one of his standard formats. Webb, a Rosering director, contributed to Rudolf Dircks' (see Figure 66) book on Sir Christopher Wren, *Bicentenary Memorial Volume*, published by the RIBA in 1923.

Institutions

Figure 137
ROSERING LIMITED, 1928
Drawing in ink on linen
12.7 x 12.4cm (5 x 4⅞in.)

Institutions

Cards, Letterheads and Other Designs

Figure 138
ANGEL AND TRAVELLER, n.d.
Print
11.8 x 10.2cm (4⅝ x 4in.)

This is an unassigned pictorial bookplate with an illustration of an angel holding a light and providing guidance or direction to a traveller. Angels were among Voysey's favourite motifs for his bookplates and wallpaper and textile designs. He made studies of angels from books on the painter Filippo Lippi, as well as *Miscellaneous Tracts Relating to Antiquity*, published by the Society of Antiquaries, which he consulted at the British Museum.

Cards, Letterheads and Other Designs

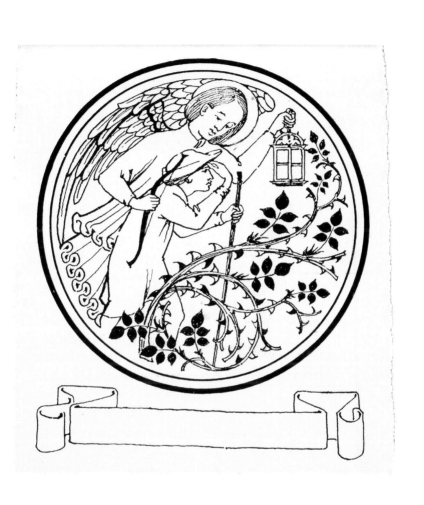

Figure 139
AUSTRALIA POSTAGE STAMP, 1911
Photostat of ink drawing
4.1 x 3.3cm (1⅝ x 1⁵⁄₁₆in.)

In 1911 a competition was held to design the first stamp for the newly unified states of Australia; it attracted over one thousand entries. This may be Voysey's competition entry and it is easy to see why such a competition would have appealed to him. In his "Symbolism in Design" he wrote that this was "Designed for an Australian stamp ... The kangaroo and eucalyptus which are peculiar and familiar emblems of that country are surrounded by wheat sheaves to suggest the great agricultural interest of that great Island".[112]

Cards, Letterheads and Other Designs

Figure 140
LITTLE LIBRARY, n.d.
Print
9.5 x 12.4cm (3¾ x 4⅞in.)

This simple design was based entirely on lettering and may have been intended as a stamp for a library of children's books.

Figure 141
MONOGRAM OF W.W.N., n.d.
Print
6.5 x 5.4cm (2⁹⁄₁₆ x 2⅛in.)

This is one of three bookplates or badges in which the design is made up of intertwined initials. Here the initials "W.W.N." are set against a coloured, chequered background.

Figure 142
FRONTISPIECE, c.1915
Print
9.5 x 4.9cm (3¾ x 1¹⁵⁄₁₆in.)

This motif was used as the frontispiece for Voysey's book *Individuality*, which was published in 1915. In the book he set out his belief that faith underpinned everything he did, both as a person and as an architect. He supported this view by explaining the symbolism of the device:

> [It] is intended to suggest that all life is anointed by the spirit. The angel, therefore, as spiritual messenger, is watering the oak, which latter is the symbol of hearty growth; we speak of hearts of oak, and so this one is sustained by the heart of man which denotes the affections, and supports likewise the raven as a symbol of animal life. Birds, like men, walk erect, and they also soar into the sky and so symbolise aspiration and spiritual activity. The raven is here chosen for its supposed wonderful sagacity. Although it has been stated that the eagle is the highest flyer and the furthest seer of any living creature.[113]

The design was also published in *The Builder* to illustrate Voysey's 1918 lecture "Modern Symbolism", given at Carpenters' Hall, London.

Cards, Letterheads and Other Designs

Figure 143
SEMPER FIDELIS, n.d.
Print
5.7 x 6cm (2¼ x 2⅜in.)

This variation on the bookplate designed for Annesley Voysey (see Figure 32) illustrates a bird feeding her young chicks, with the motto "Semper fidelis" (Always faithful) around the bottom edge of the design.

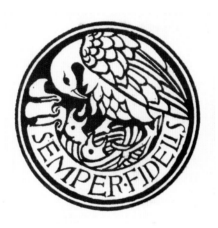

Figure 144
CUPID, 1932
Print
5.2 x 3.3cm (2⅟₁₆ x 1⅟₁₆in.)

This design for a cupid is recorded in the Crab Tree Farm album, with a note beside it in Voysey's handwriting that identifies it as "not my own". However, his ledger of professional expenses for 29 July and 2 August 1932 shows that he paid six shillings and nine pence for "Sun prints of Cupid 1st sheet + neg." and "Expenses for Cupid Design"; he ordered further prints on 5 August. The entry for this design in "Symbolism in Design" describes it as "for tail piece of a book", though this is struck through.[114] A 1932 entry in Voysey's "Black Book" notes that he "Designed and Coloured 936 Cupids. 448 Given Away. Profit £11.4.0". One of these coloured Valentines, given to his daughter-in-law Denise (see Figure 29), is now preserved in the collection of the RIBA, with a hand-written message from Voysey on the front:

> Con amore
> to Denise Cowles-Voysey
> from C.F.A. Voysey.
> Fecit.

On the back, he wrote:

> Loving thoughts like arrows
> Although I fail to catch
> Youre [*sic*] eye

Cards, Letterheads and Other Designs

not my own.

Figure 145
SYMPATHY CARD, n.d.
Print with added colour
11.4 x 8.9cm (4½ x 3½in.)

My messengers are here to tell,
the feelings that I fail to show, but
with your sympathy I know +
you'll know ⚜ ⚜ ⚜ ⚜

Figure 146
CHRISTMAS CARD, n.d.
Print with added colour
6 x 12.7cm (2⅜ x 5in.)

Voysey drew designs for cards and invitations to mark a variety of occasions, for both himself and his family, friends and the clubs that he was associated with. This Christmas card was designed for his niece, Ella, and her husband, the actor Robert Donat (see Figures 39 and 40). Both this and the sympathy card in the album (see Figure 145) include Voysey's distinctive lettering and one of his favourite motifs, angels.

Cards, Letterheads and Other Designs

TO ✝ WISH ✝ YOU ✝ A ✝ HAPPY ✝
CHRISTMAS ✝ WITH ✝ HEALTH
AND ✝ PROSPERITY ✝ IN ✝ THE ✝
NEW ✝ YEAR ✝ FROM ✝ ELLA ✝
AND ✝ ROBERT ✝ DONAT ✝ ✝

Figure 147
BADGE FOR SIR WALTER ESSEX'S HONEY, n.d.
Print
7 x 5.2cm (2¾ x 2¹⁄₁₆in.)

Sir Richard Walter Essex, founder of Essex & Co. wallpaper company (see Figure 49), one of the first manufacturers to produce Voysey's designs, had a home in Bourton on the Water, Gloucestershire. Voysey designed this label or badge for the jars of honey produced at Essex's home.

Cards, Letterheads and Other Designs

Badge for Sir Walter
Essex's honey.

Figure 148

A FESTIVAL OF ENGLISH CHURCH ART, 1930
Advertisement (from a magazine)
15.9 x 10.5cm (6¼ x 4⅛in.)

This is one of many examples of designs for leaflets, advertisements, posters, invitations and certificates that Voysey was called upon to produce. The format suited his style perfectly and he was able to draw on his favourite symbolic motifs and lettering techniques. This design is reminiscent of the images that Voysey would have seen in *The Hobby Horse*, a magazine first produced in 1884 by The Century Guild, which heavily influenced him (see Figure 20). It was published by the De La More Press, London, which was founded by Alexander Moring in 1895 to produce ordinary commercial work in a manner worthy of the craft.

The Festival of English Church Art was a range of events organised in 1930; it included organ recitals, communions, demonstrations, lectures and an exhibition at Caxton Hall, near Westminster Abbey, London. The festival's aims were to spread knowledge and encourage a deeper understanding of Anglican Communion, as well as to promote fine craftsmanship and the work of leading artists in church building and decoration.

Cards, Letterheads and Other Designs

FESTIVAL of ENGLISH CHURCH ART

Westminster 16th June - 2nd July 1930

Festival Offices Church House Westminster

THE ABBEY · CHRIST CHURCH · WESTMINSTER · CAXTON HALL

Figure 149
PLAYING CARD, 1932
Drawing in ink and watercolour
9.8 x 6.8cm (3⅞ x 2¹¹⁄₁₆in.)

Voysey's ledger of professional expenses notes that he paid two shillings and six pence for "6 prints of design for card back" on 6 July 1932. In "Symbolism in Design" he wrote:

> This is a design for the back of playing cards. The knave has his coat decorated with dice boxes, as belief in chance and laws only of his perverted mind, are essential to his knavish tricks. The Queen being a pure lady, has her robes emblazoned with fleur-de-lis. The King has ermine for his coat, The Knave seeks to charm his Queen with the symbol of love, like a true knave, it is the symbol only that he relies upon, and not what it stands for. Let us all learn to love that which is symbolised and never sink into materialistic contentment with the symbol only, for it is the concentration of the mind on the material manifestation, rather than on the spirit expressed, that has led us to extravagant over-estimation of the value of a name. We glorify the names of men before we have learned to love their highest qualities. We forget that works of art are to be valued according to their spiritual qualities, the messages of love that they are created to convey, and the emotions they are destined to arouse. It is only when we are blind to these qualities that we seek a guide to our judgements in the names of authors, and appropriate the opinions of others, without making any effort of thought ourselves.[115]

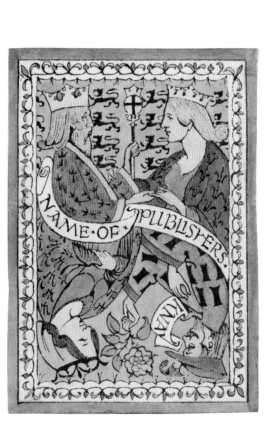

Notes

1. Voysey 1930-32.
2. Gleeson White, "Modern Bookplates and Their Designers", *The Studio* Special Winter Number (1898-99), p. 11.
3. Gleeson White, "Designing for Bookplates; With Some Recent Examples", *The Studio* 1 (1893), p. 24.
4. The journal was called the *Journal of the Ex Libris Society* and was published between 1891 and 1908.
5. White (note 2), p. 14.
6. See "Ernest Gimson and the Arts and Crafts Movement in Leicester," http://gimson.leicester.gov.uk/vm/egc/dnd/bp.
7. See White 1995.
8. Aymer Vallance, "Designs for Bookplates. Some Remarks upon the Results of Competition B XX", *The Studio* 27 (1903), pp. 120-29.
9. Gleeson White, "Notes on Recent Bookplates (Ex Libris)", *The Studio* 4 (1894), p. 200.
10. "Bookplates and Badges by C.F.A. Voysey", *The Studio* 64 (1915), pp. 50-51.
11. Voysey 1915.
12. "C.F. Annesley Voysey: The Man and His Work", *The Architect and Building News* 117 (1927), p. 405.
13. "An Interview with Mr. Charles Annesley Voysey, Architect and Designer", *The Studio* 6, 1 (Apr. 1893), pp. 231-37.
14. Voysey 1931, p. 4.
15. Webster 1995, pp. 63-66.
16. Voysey 1930-32, no. 8.
17. C.F.A. Voysey, "1874 and After", *Architectural Review* 70 (Oct. 1931), p. 92.
18. Voysey 1930-32.
19. C.F.A. Voysey, "Carpenters' Hall Lectures: Modern Symbolism", *The Builder* 114 (8 Mar. 1918), p. 157.
20. Review of *Individuality*, *The Burlington Magazine for Connoisseurs* 27, 149 (Aug. 1915), p. 201.
21. Voysey 1930-32.
22. Ibid., p. 5.
23. Basil Oliver, "The Late C.F.A. Voysey", *The Builder* (21 Feb. 1941), p. 197.
24. C.F.A. Voysey in a lecture to the Architectural Society of the Bartlett School, published in summary in *The RIBA Journal* 41 (1934), p.479.
25. Voysey 1930-32, no. 72.
26. "An Interview with Mr. Charles Annesley Voysey …", (note 13), p. 232.
27. Voysey 1930-32, no. 73.
28. Ibid., no. 32.
29. Ibid., no. 14.
30. Ibid., no. 29.
31. Ibid., no. 21.
32. Ibid.
33. Ibid., no. 36.
34. Ibid., no. 71.
35. Robert Donat, "Uncle Charles", *The Architect's Journal* 92 (20 Mar. 1941), p. 194.
36. Voysey 1930-32, no. 54.
37. Quoted in Philip French, "Philip French's Screen Legends", *The Observer*, 19 Apr. 2009, p. 15.
38. Donat (note 35).
39. Hitchmough 1995, p. 234.
40. Voysey 1930-32, no. 30.
41. Quoted in Hitchmough 1995, p. 99.
42. Voysey 1930-32, no. 15.
43. Ibid., no. 22.
44. Ibid., no. 34.
45. Ibid., no. 33.
46. Ibid., no. 9.
47. Ibid., no. 37.
48. Ibid., no. 20.
49. Ibid., no. 2.
50. Ibid., no. 40.
51. This design is in the RIBA Drawings Collection, Voysey 500/2.
52. Voysey 1930-32, no. 68.
53. Ibid., no. 61.
54. Ibid., no. 48.
55. Ibid., no. 64.

56. Ibid., no. 75.
57. Ibid., no. 53.
58. Letter from Arnold Mitchell to Charles Cowles-Voysey, 13 Feb. 1941. RIBA Archives, VOC/6/10/5.
59. Voysey 1930-32, no. 25.
60. "Articles of Apprenticeship between Robert Haslam and C.F.A. Voysey", 6 Dec. 1895. RIBA Archives.
61. Letter from Voysey to William Haslam, 8 Oct. 1898. RIBA Archives, HAR/1/1/2.
62. Voysey 1930-32, no. 13.
63. Ibid., no. 74
64. Ibid.
65. Ibid., no. 3.
66. "The Library and Collections of the Institute: Discussion of the Foregoing Paper", *Journal of the RIBA* 28 (Nov. 1920-Oct. 1921), p. 91.
67. Voysey 1930-32, no. 55.
68. This poem is in the RIBA Drawings Collection, Voysey 640.
69. Voysey 1930-32, no. 58.
70. Ibid., no. 63.
71. Ibid., no. 43A.
72. Ibid., no. 56.
73. Ibid., no. 57.
74. Ibid., no. 19.
75. Ibid., no. 60.
76. Ibid., no. 31.
77. Ibid., no. 6.
78. Ibid., no. 17.
79. Ibid., no. 23.
80. Ibid., no. 18.
81. This work is in the RIBA Drawings Collection, Voysey 470.
82. This work is in the RIBA Drawings Collection, Voysey 506.
83. Voysey 1930-32, no. 62A.
84. Ibid., no. 65.
85. Ibid., no. 62.
86. Ibid., no. 38.
87. Ibid., no. 49.
88. Ibid., no. 50.
89. Ibid., no. 59.
90. The reference number for this drawing is Voysey 533.
91. Voysey 1930-32, no. 1.
92. Ibid., no. 39.
93. Ibid., no. 7.
94. Archives of King Alfred's School, courtesy of Brian Rance, Archivist.
95. Voysey 1930-32, no. 52.
96. This letter is in the RIBA Drawings Collection, Voysey 481.
97. Margaret Elliot, *Prior's Field School: A Century to Remember, 1902-2002* (Prior's Field School Trust, 2002), p. 11. Courtesy of Saadet Payne, Prior's Field School.
98. Announcement of the opening of the Design Club, *The Builder* 96 (1909), pp. 235-36.
99. Ibid.
100. Voysey 1930-32, no. 51.
101. Ibid., no. 66.
102. Ibid., no. 67.
103. Ibid.
104. Ibid., no. 10.
105. Ibid., no. 42.
106. Hitchmough 1995, p. 196.
107. Voysey 1930-32, no. 4.
108. Ibid., no. 24.
109. Ibid., no. 45.
110. "Charles Annesley Voysey: Royal Gold Medallist", *RIBA Journal* 47 (18 Mar. 1940), p. 18.
111. "The RIBA Badge. The Story of Variations on a Theme", *Journal of the RIBA* (14 Apr. 1934), pp. 566-69.
112. Voysey 1930-32, no. 16.
113. Ibid., no. 1.
114. Ibid., no. 57A.
115. Ibid., no. 41.

Selected Bibliography

Voysey and the Arts and Crafts Movement

Brandon-Jones, John. 1957. "C.F.A. Voysey, 1857-1941". *Architectural Association Journal* 28, pp. 239-62.

———. 1963. "C.F.A. Voysey". In *Victorian Architecture*, edited by Peter Ferriday, pp. 267-87. J. Cape.

———, et al. 1978. *C.F.A. Voysey: Architect and Designer, 1857-1941*. Exh. cat. Lund Humphries/Art Gallery and Museums and the Royal Pavilion, Brighton.

Durant, Stuart. 1990. *The Decorative Designs of C.F.A. Voysey*. Lutterworth Press.

Gebhard, David. 1975. *Charles F.A. Voysey, Architect*. Hennessey & Ingalls.

Hitchmough, Wendy. 1995. *C.F.A. Voysey*. Phaidon.

Hunterian Art Gallery. 1993. *C.F.A. Voysey: Decorative Design*. Exh. cat. Hunterian Art Gallery.

Jackson, Lesley. 2002. *Twentieth-Century Pattern Design: Textile and Wallpaper Pioneers*. Princeton Architectural Press.

Johnson, Alan. 1977. "C.F.A. Voysey and the Architecture of Moral Reform". *Architectural Association Quarterly* 9, 4, pp. 26-35.

Livingstone, Karen, and Linda Parry, eds. 2005. *International Arts and Crafts*. Exh. cat. V&A/Harry N. Abrams.

Parry, Linda. 1988. *Textiles of the Arts and Crafts Movement*. Thames and Hudson.

Richardson, Margaret. 1983. *Architects of the Arts and Crafts Movement*. Trefoil Books.

Simpson, Duncan. 1979. *C.F.A. Voysey: An Architect of Individuality*. Lund Humphries.

Symonds, Joanna. 1976. *Catalogue of the Drawings Collection of the Royal Institute of British Architects: C.F.A. Voysey*. Gregg International Publ.

Voysey, C.F.A. 1915. *Individuality*. Chapman and Hall.

— — —. 1930-32. "Symbolism in Design". Unpublished manuscript, RIBA Archives.

— — —. 1931. "The Value of Hidden Influences as Disclosed in the Life of One Ordinary Man". Unpublished manuscript, RIBA Archives.

Webster, J.R. 1995. *Old College, Aberystwyth: The Evolution of a High Victorian Building*. University of Wales Press.

Bookplates

The Bookplate Society, and the Victoria and Albert Museum. 1979. *A Brief History of Bookplates in Britain*. Exh. cat. H.M.S.O.

Lee, Brian North. 1982. "Pictorial Bookplates in Britain". *The Private Library* 3, 5, 2.

— — —. 1991. *Bookplate Collecting in Britain: Past and Present*. The Bookplate Society/Apsley House Press.

— — —. 2006. "Rare Modern British Ex-Libris". *Bookplate Journal* 4, 1 (Mar.), pp. 3-13.

White, Colin. 1995. "The Bookplate Designs of Jessie M. King". *The Bookplate Journal* 13, 1 (Mar.), pp. 3-29.

Acknowledgements

Many people contribute and provide support when writing a book such as this, but first there has to be an idea. The idea for this book came from John Bryan and Tim Gleason, who are great friends and mentors in our world of Arts and Crafts. Thank you sincerely to them both for thinking of me as the person who could articulate their vision.

Dr. Geoffrey Vevers, secretary of The Bookplate Society, has been an untiring and enthusiastic supporter of this book from its earliest stages and has generously shared his expertise and time with me, as well as granting permission to illustrate bookplates from his own collection. Many thanks to The Bookplate Society for selecting this book as their biennial book of the year. Thanks are also due to the American Society of Bookplates and the Wilyman Collection for allowing us to include examples of bookplates from their collections in this publication.

Linda Parry has, as always, been an inspiration, and many others including Jonathan Bennett, Mark Eastment, Morag Livingstone, my parents Rona and Maitland Livingstone, and Ghislaine Wood have offered support, interest and enthusiasm throughout the many months of research and writing. Wendy Hitchmough gave up her time to talk to me about Voysey and offered numerous helpful insights. Paul Gehl of the Newberry Library was helpful in determining the printing technique for each bookplate.

I have consulted many libraries and archives in researching this book. I should especially like to thank the staff at the Royal Institute of British Architects for their patience and assistance. Brian Rance of King Alfred's School Society and Saadet Payne of Prior's Field School provided very useful information from their archives.

Thank you to Prim Elliott and Diana Steel at the Antique Collectors' Club for their expert management and production of this book. Steve Farrow has

worked very hard on the design for the book, with delightful and elegant results. And last, but not least, thank you to Kim Coventry who has been a passionate guide and a patient editor of this book from the very beginning.

✿　✿　✿　✿　✿

Note to the Reader

The author has made every effort to identify correctly and date the bookplates featured in this book and to establish the biographical details of the people for whom they were designed. She would be happy to be notified of any errors, omissions or new information that readers may be able to provide.

Every effort has been made to reproduce the bookplates at actual size. However, because of the way Voysey pasted them into the album (in some cases overlapping), photography proved to be difficult and this has sometimes affected the scale of reproduction. The album contains some duplicate prints, but all have been included here for the sake of completeness.

Index